The Journal of Modern Craft

Volume 2—Issue 3—November 2009

Editors
Glenn Adamson
Tanya Harrod
Edward S. Cooke, Jr.

Editors
Glenn Adamson
Victoria & Albert Museum, London (UK)

Tanya Harrod
Royal College of Art, London (UK)

Edward S. Cooke, Jr.
Yale University (USA)

Book Review Editor
Kevin Murray
Craft Writer (Australia)

Exhibition Review Editor
Louise Mazanti
Konstfack, Stockholm (Sweden)

International Advisory Board
Dapo Adeniyi
Position International Arts Review (Nigeria)

Charlotte Brown
Gregg Museum of Art & Design,
NC State University (USA)

Alan Crawford
Independent Scholar (UK)

Edmund de Waal
Ceramist and Historian (UK)

John Dunnigan
Rhode Island School of Design (USA)

Simon Fraser
Central St. Martins College of Art and Design (UK)

Alun Graves
Victoria & Albert Museum (UK)

Louise Hamby
Australian National University (Australia)

Fujita Haruhiko
Osaka University (Japan)

Bernard Herman
University of North Carolina (USA)

Gloria Hickey
Independent Scholar (Canada)

Rosemary Hill
Independent Scholar (UK)

Jyotindra Jain
Jawaharlal Nehru University (India)

Janis Jefferies
Goldsmiths (UK)

Rüdiger Joppien
Museum für Kunst und Gewerbe (Germany)

Gerhardt Knodel
Former Director, Cranbrook Academy of Art (USA)

Janet Koplos
Independent Scholar (USA)

Henrietta Lidchi
National Museums of Scotland (UK)

Martina Margetts
Royal College of Art (UK)

Simon Olding
Crafts Study Centre, Farnham (UK)

Gerald L. Pocius
Memorial University of Newfoundland (Canada)

Venetia Porter
British Museum (UK)

Nakayama Shuichi
Kobe University (Japan)

Jorunn Veiteberg
University of Bergen and University of Oslo (Norway)

Anne Wilson
School of the Art Institute of Chicago (USA)

Aims and Scope
The Journal of Modern Craft is the first peer-reviewed academic journal to provide an interdisciplinary and international forum in its subject area. It addresses all forms of making that self-consciously set themselves apart from mass production—whether in the making of designed objects, artworks, buildings, or other artefacts.

The journal covers craft in all its historical and contemporary manifestations, from the mid-nineteenth century, when handwork was first consciously framed in opposition to industrialization, through to the present day, when ideas once confined to the "applied arts" have come to seem vital across a huge range of cultural activities. Special emphasis is placed on studio practice, and on the transformations of indigenous forms of craft activity throughout the world. The journal also reviews and analyzes the relevance of craft within new media, folk art, architecture, design, contemporary art and other fields.

The Journal of Modern Craft is the main scholarly voice on the subject of craft, conceived both as an idea and as a field of practice in its own right.

Submissions
To submit an article for consideration please contact Glenn Adamson at g.adamson@vam.ac.uk

Subscription Information
Three issues per volume. One volume per annum. 2009: volume 2

Online
www.bergjournals.com/journalofmoderncraft

By Mail
Berg Publishers
C/o Customer Services
Turpin Distribution
Pegasus Drive
Stratton Business Park
Biggleswade
Bedfordshire SG18 8TQ
UK

By Fax
+44 (0)1767 601640

By Telephone
+44 (0)1767 604951

Subscription Rates
Institutional:
Print and online: 1 year: £163/US$317; 2 year: £260/US$508
(VAT charged if applicable)

Individual:
Print: 1 year: £25/US$48; 2 year: £45/US$87

Full color images available online
Access your electronic subscription through
www.ingentaconnect.com

Reprints for Mailing
Copies of individual articles may be obtained from the publishers at the appropriate fees. For information, write to

Berg Publishers
1st Floor, Angel Court
81 St Clements Street
Oxford OX4 1AW
UK

Inquiries
Editorial:
Julia Hall, email: jhall@bergpublishers.com

Production:
Ken Bruce, email: kbruce@bergpublishers.com

Advertising:
Corina Kapinos, email: ckapinos@bergpublishers.com

Berg Publishers is a member of CrossRef

The Journal of Modern Craft is indexed by Abstracts in Anthropology; DAAI (Design & Applied Arts Index).

© 2009 Berg. All rights reserved. No part of this publication may be reproduced or utilized in any form or by any means, electronic or mechanical, including photocopying and recording, or in any information storage or retrieval system without permission in writing from the publisher.

ISSN 1749-6772

Typeset by JS Typesetting Ltd, Porthcawl, Mid Glamorgan

Printed in the UK by Henry Ling

The Journal of Modern Craft

Volume 2—Issue 3—November 2009

Contents

Editorial Introduction	**247**

Articles

A Ghost in the Machine Age: The Westerwald Stoneware Industry and German Design Reform, 1900–1914. Freyja Hartzell	**251**
A Catalan Werkstätte? Arts and Crafts Schools between *Modernisme* and *Noucentisme*. Jordi Falgàs	**279**
Early Expressions of Anthroposophical Design in America: The Influence of Rudolf Steiner and Fritz Westhoff on Wharton Esherick. Roberta A. Mayer and Mark Sfirri	**299**

Primary Text

Commentary. Paul Caffrey	**325**
Design in Ireland: Report of the Scandinavian Design Group in Ireland, April 1861.	**331**

Statement of Practice

Handspring Puppet Company. Adrian Kohler, Basil Jones and Tommy Luther	**345**

Exhibition Reviews

Craft in its Gaseous State: *Wouldn't It Be Nice ... Wishful Thinking in Art and Design*. Mònica Gaspar	**355**
Quiet Persuasion: *Political Craft*. Geraldine Craig	**359**

Book Reviews

A Theory of Craft: Function and Aesthetic Expression. Reviewed by Sandra Alfoldy	**363**
Designing Modern Britain. Reviewed by Peter Hughes	**367**

INSPIRING CRAFT BOOKS

9781408112663 • **£30**

9780713675184 • **£15.99**

9780713687323 • **£30**

9781408119983 • **£19.99**

9781408101032 • **£15.99**

9781408115534 • **£16.99**

9780713682472 • **£14.99**

9781408112670 • **£14.99**

9781408100752 • **£30**

BUY NOW!
Available from good bookshops, or to order direct contact:
tel: 01256 302699 email: direct@macmillan.co.uk
For all visual arts title visit: **www.acblack.com**

Editorial Introduction

Almost two years ago now, the *Journal of Modern Craft*'s first editorial argued for a broad framing of our subject, one that would go beyond the studio crafts and their discrete disciplines, as well as the tendency to place craft in a series of continuous dialectics with modernity, industrialization, commerce, and fine art aesthetics. Our first Primary Text, by the late Reyner Banham, argued for an authentic species of craft embedded (and buried, out of view) within the routines of the factory. In more recent issues we have continued to seek out scholarship on craft well outside "movement" logic, in contexts such as tourist economies, public art performance, and industrial design.

Yet the area of academic study most closely associated with the word "craft" remains, of course, the Arts and Crafts movement. In that first editorial we expressed the hope that a major study would emerge that tackled the movement's complexity and paradoxical nature. Gillian Naylor's *The Arts and Crafts Movement: A Study of Its Sources, Ideals and Influence on Design Theory*, first published in 1971, set the bar high. It is salutary to consider that although there has been much valuable infilling in the form of newly discovered objects, good international surveys, monographs on individual figures, and detailed regional studies—both in our own pages, and in such exemplary recent publications as Lawrence Kreisman and Glenn Mason's *The Arts and Crafts Movement in the Pacific Northwest*—there has been nothing quite as energetic, incisive and politically aware as Naylor's pioneering contribution, written nearly forty years ago.

The last fresh contextualization of the Arts and Crafts movement was the decisive turn to Romantic Nationalism, a diffusionist approach that informed Elizabeth Cumming and Wendy Kaplan's succinct, admirable 1991 *The Arts and Crafts Movement* in the World of Art series and the papers in *Art and the National Dream* (1993) edited by Nicola Gordon Bowe. A key moment for reframing Arts and Crafts studies should have been 2005—when two major exhibitions were mounted (at the Victoria and Albert Museum and at Los Angeles County Museum). Both, however, were chiefly informed by Romantic Nationalist scholarship, choosing to explore the international nature of the movement by tracking its dissemination country by country. When nationalist agendas are examined in relative isolation, we miss the

opportunities to see what is common to different experiences of craft reform, what hybrids develop, and why. Craft movements do not chart a simple, linear process of influence, but rather a series of asymmetrical and overlapping fits and starts.

Then there is the question of the relationship between the Arts and Crafts movement and later developments within modern craft and design. Alan Crawford's remarkable, modestly entitled "The Arts and Crafts Movement: A Sketch"—in Alan Crawford (ed.), *By Hammer and By Hand: The Arts and Crafts Movement in Birmingham*, 1984—showed the way. As Tom Crook argued in our first issue of this year, the Arts and Crafts movement should be viewed as presenting an alternative option within (rather than an escape from) modernity, and its political and aesthetic transformations. A logical corollary is that historians should look beyond the chronological boundaries of the Arts and Crafts movement, finding continuities that might reshape our understanding of early modernism in design and architecture, and uncovering hidden stories of craft hitherto obscured by an interwar rhetoric of progressive technology.

And there are plenty of other possibilities for further research. These might include the investigation of workshop practice and engagement with materials—themes intrinsic to the Arts and Crafts movement's pedagogy, both informal and formal, and transmitted through permissible tools, and the study of historic and vernacular material. This could tie in with an investigation of time consumption and normative work practices during the high period of the Arts and Crafts movement. John Roberts's Marxist-inflected art historical study, *The Intangibilities of Form:*

Skill and Deskilling in Art After the Readymade, suggests the potential for using a labor theory of culture as a model to investigate Arts and Crafts values. Equally, a history of colonial art education would show Arts and Crafts values being deployed and depleted in strategies of underdevelopment.

The research articles included in this issue suggest the rich possibilities afforded by some of these approaches. Each essay presents craft reform as inextricably bound to modern innovations, whether those occur in the registers of mass production, urban reinvention, or spiritual experimentation.

Freyja Hartzell offers a sharply observed account of the stonewares produced in the Westerwald of Germany at the turn of the century. She shows how designers such as Richard Riemerschmid appropriated the *völkisch* emblems of vernacular ceramic production in the service of a modern German material culture. Jordi Falgàs tracks the transmission of these German ideas to the town of Girona in Spain, where the progressive architect Rafael Masó tried to put similar principles into practice. If Riemerschmid and his colleagues enjoyed success in reframing craft within an ideologically driven reform movement, Masó's story is fascinating partly because of his failures. In the politically fractured context of Catalonia, artisanal architecture was impossible not because it was mute, but because it spoke all too clearly. Our third article brings us forward in time to the seam between the Arts and Crafts era and the emergence of an individualist studio craft movement. Art historian Roberta Meyer and master woodworker Mark Sfirri place the iconic figure of Wharton Esherick— often described as the first American studio

furniture maker—into the surprising context of 1920s international anthroposophy. Meyer and Sfirri show that the motifs and intent of Esherick's furniture conform closely to the teachings of this modernist spiritualist movement, pioneered by the Austro-Hungarian philosopher Rudolf Steiner.

All three articles attest to the importance of in-depth primary research in the effort to come to grips with the historical craft movement. In this spirit, we offer a Primary Text that takes us further forward in time to the postwar period, but not necessarily away from turn-of-the-century preoccupations. Paul Caffrey introduces us to a fascinating document of 1960s design reform, the so-called "Scandinavian Report," in which a team of visiting designers frankly appraise the strengths and weaknesses of Irish craft and industrial production. It is fascinating to observe some of the same issues that were at issue in Germany and Spain, c.1900—such as the proper deployment of folk motifs and the ideal organization of workshops—still at issue in this very different chronological and geographical situation.

Finally, we have a Statement of Practice by the founders of the Handspring Puppet Company, who are based in South Africa but have taken London by storm recently in the theatrical production *War Horse*. They argue that the contemporary puppet is a unique form of craft because its "ur-narrative" is a functional commitment to "seeming to be alive." There are many subtle ways in which this absorbing account of puppet design connects with Arts and Crafts studies—by allying craftedness with radical modernity, through its global references and inspirations, through puppetry's implicit commentary on individual agency and, not least, in a shared ambition to create a constructed object with a narrative, animate purpose.

The Editors
The Journal of Modern Craft

A Ghost in the Machine Age: The Westerwald Stoneware Industry and German Design Reform, 1900–1914

Freyja Hartzell

Freyja Hartzell is a doctoral candidate in the History of Art at Yale University. She holds a BA in Art and Art History from Grinnell College and MAs from the Bard Graduate Center for Studies in the Decorative Arts, Design and Culture and from Yale University. Her dissertation on German design reform and cultural aesthetics, "Delight in *Sachlichkeit*: Richard Riemerschmid and the Thingliness of Things," explores the Munich artist's designs for the domestic interior as a primary locus of aesthetic and cultural transformation during the modern period.

Abstract

Between the Paris Exposition Universelle in 1900 and the Deutscher Werkbund's first major exhibition of mass-produced products in Cologne in 1914, German stoneware underwent a remarkable process of technical and aesthetic modernization. In collaboration with artists and cultural critics, the German region known as the Westerwald transformed its provincial, handcrafted vessels to rank among the exemplary mass-produced goods selected and deployed by the Werkbund to promote—at a domestic, grass-roots level—the development of a modern, national style. But this modern transformation was complicated by the legacy of the past: the Westerwald's heritage of indigenous craft affected its manufacture of modern products. This article traces the Westerwald's paradoxical approach to modern design as a reflection of Wilhelmine Germany's ambivalent modernism and employs "modern" stonewares in an

interpretation of the Werkbund's vision for a technological future conflated with a vernacular past. Analysis of Westerwald vessels designed by influential modern artists and displayed, published and marketed by the Werkbund, helps to concretize the organization's notoriously elusive design theory, including its specialized use of the terms *Qualität* and *Sachlichkeit*. To a young German nation in search of an enduring, all-pervasive, national style, the Westerwald offered an "evolved" vernacular fit for modern consumption.

Keywords: Deutscher Werkbund, *Kultur*, modern design, *Qualität*, Richard Riemerschmid, *Sachlichkeit*, vernacular, Westerwald

> No matter where the whims of fashion may lead, the beer mug will always stick with stoneware.[1]

An "Artistic Emergency"

At the turn of the twentieth century, the German stoneware industry found itself in aesthetic and economic crisis. The Kannenbäckerland, or "Jug-Baking Country"—the small region of western Germany to the east of the Rhine, between the Rivers Sieg and Lahn, and situated in the southwestern portion of the Westerwald (western forest) mountain range—had seen better days. Kannenbäckerland had earned its nickname for five centuries of utilitarian pottery production—five hundred years of cobalt-stained, salt-glazed tankards, jugs and punchbowls known as Westerwald stoneware. Three primary production centers at Höhr, Grenzau and Grenzhausen, grew up around the lower or "Unterer" Westerwald mountains, which contained the largest and richest deposits of stoneware clay constituents in northwest Europe. This natural, material resource fueled the development of the Westerwald industry, from its fourteenth-century production for local markets to its international renown in the sixteenth and seventeenth centuries.[2]

The material character of Westerwald clay—fine-grained and plastic, yet durable and sanitary owing to its high firing temperature—suited it not only to a variety of utilitarian, domestic forms (from preserving jars to chamber pots), but also to the elaborately embellished drinking vessels that became fashionable during the sixteenth century and won the Westerwald potters recognition as fine craftsmen (Figure 1).[3] Rhineland beer mugs and kitchen crockery, traded across Europe and Britain and exported as far as North America, Africa and Asia, came to be identified with reliability and authenticity: the word "Westerwald" spoke of German quality.[4]

By the eighteenth century, Westerwald stoneware had secured a reputation for usefulness; but by the nineteenth century this reputation was all it had left. The eighteenth century saw Westerwald stoneware already assuming a narrower market niche as primarily functional pottery, appropriate to the utilitarian needs that imported fine-ware (e.g. tin-glazed earthenware) failed to meet; but the discovery of kaolin near Dresden in the early eighteenth century and the rapid development of European porcelain that followed foretold the total eclipse of Westerwald stoneware as a decorative ceramic.[5] During the nineteenth

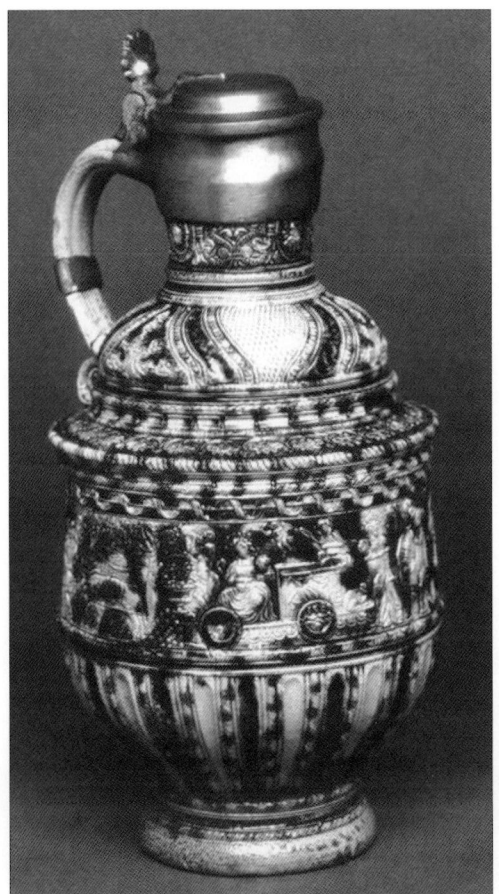

Fig 1 Large baluster jug with applied body frieze depicting the Triumphal Procession of the Four Seasons, date of 1589 and initials "IE" for Jan Emens, a potter who relocated from Raeren to Grenzau during the 1580s. The shoulder features stamped floral motifs and incised diaper ornament [*Kerbschnitt*]. © The Trustees of the British Museum.

of economic boom following Germany's 1871 victory in the Franco-Prussian War and subsequent unification. But their intricate copies of German Renaissance vessels, though technologically progressive, attracted only fleeting consumer interest (Figure 2).[6] By 1900, flea markets were flooded with blue-and-gray beer mugs so stripped of market value that their pewter lids constituted their greatest material asset.[7]

At the 1900 Paris Exposition Universelle, the juxtaposition of "dusty" Westerwald stoneware with the dazzling spectrum of glazes and innovative, Asian-inspired forms of French "art pottery" proved humiliating, not only for the Rhineland firms, but for the new German nation. In desperation (and with Prussian government support)

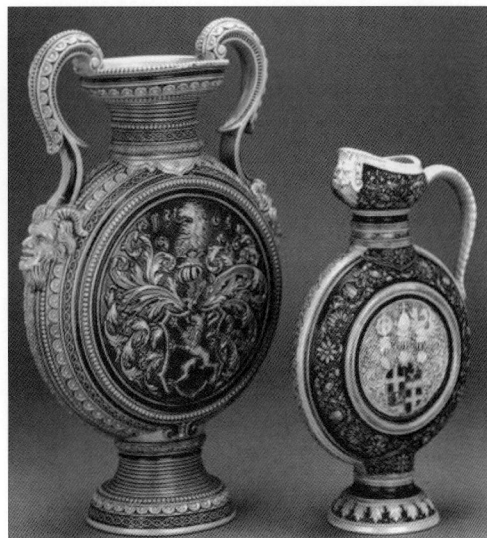

century, as porcelain became increasingly affordable to the middle classes for everyday use, stoneware began to seem downright crude. The Westerwald firms rallied to the nationalism of the *Gründerzeit*: the period

Fig 2 Left: jug, stoneware with iron-oxide, Merkelbach & Wick, Grenzhausen, 1873. Right: jug, stoneware with cobalt-oxide, designed and modeled by Peter Dümler, S.P. Gerz, Höhr, c. 1878–83. © The Trustees of the British Museum.

the Westerwald turned to progressive German artists for a solution to its "artistic emergency."[8] The Westerwald's collaborative response to this calamity, in its struggle for survival at the dawn of the machine age, presents two fundamental paradoxes: first, how the hallmarks of handcraft could live on in the design of industrial products; and second, how the symbols of an outmoded, regional tradition could provide the "raw materials" for a modern, national style. The story of the Westerwald's modernization from 1900 through 1914 illuminates the rhetoric of craft within the language of modern design.

The Quality of "Thingliness"

In an 1899 article for the Munich journal *Kunst und Handwerk* (Art and Handcraft) entitled "The Artistic Emergency of the Westerwald Stoneware Industry," applied arts professor Ernst Zimmermann explored the complexities of Rhineland stoneware's contemporary dilemma. Its modern problems, he argued, could not be solved simply by reclothing Westerwald vessels in historicist forms; nor could one superficially "tart up" the somber stonewares with flashy, low-fired colored enamels applied after the glaze firing.[9] The 1890s had witnessed the economic failure of both strategies. But if the emergency could not be remedied by fashion, then how could Westerwald stonewares be made to appeal to modern German consumers, yet retain their dignity as time-honored products of Germany's cultural heritage?

Two interdependent concepts—each gathering heightened significance in the discourses of architecture and design roughly contemporaneous with Zimmermann's Westerwald lament—together offered a means of rejuvenation untainted by the novelties of fashion and rooted in the German soil. These were *Qualität*: a specialized adaptation of the more generic "quality," endowing material characteristics with cultural values; and *Sachlichkeit*: generally translated as matter-of-factness, sobriety, or objectivity, but more literally interpreted as "thingliness"—the essential nature, or character, of material things. *Sachlichkeit* was first applied to the designed environment in 1896, when Munich architect Richard Streiter employed the term to describe a new "realistic architecture" that rejected the pomp of historicist styles, embracing instead utilitarian purpose, current living conditions, and local and regional building traditions, as well as locally available materials and technologies. Streiter believed that the "character" of a building or object should be derived "from the qualities of available materials, and from the environmentally and historically conditioned feeling of the place."[10] The appearance and texture of regional or vernacular materials—like the cobalt-stained, salt-glazed skin of Westerwald stoneware—signaled *Sachlichkeit* in design. The *sachliche* object discarded fashion's seductive veneer and proclaimed its own inner substance, its physical nature and ideological essence, directly through an emphasis on the characteristics of its materials and its method of construction.

Zimmermann's reform strategy for the Westerwald, stemming from a dual appreciation for its material product and its cultural heritage, was pure *Sachlichkeit*. He believed that modern artistic and

technological reforms must engage not merely with visible surface but with practical and ideological substance, with "the actual, current circumstances in the ceramics industry, which are the direct result of its history and fundamental character (*Bodenbeschaffenheit*)."[11] Zimmermann's opposition of the term *Bodenbeschaffenheit* (literally, "ground-character"), with words like novelty and fashion, set the tone for the Westerwald's twentieth-century modernization, grounded in the "character" of the clay itself. At *Sachlichkeit*'s expressive heart lay a hard kernel of materiality that would be celebrated, theorized and eventually proselytized as *Qualität*.

Between the Westerwald's embarrassment at Paris in 1900 and the 1907 founding of the Deutscher Werkbund—the organization of artists, architects, educators and industrialists who targeted the applied arts as the key to a modern German aesthetic culture—the indigenous Rhineland industry would undergo rigorous technical and aesthetic modernization. The collaboration among manufacturers, technicians and artists necessary to achieve its reincarnation would stand as a model for the Werkbund's symbiotic vision for art and industry. The product of this union was envisioned as a useful, affordable *Alltagskunst*, or "everyday art." This new *Alltagskunst* should establish a modern German style rooted so deeply in German culture that it could weather the whims of fashion, and integrated so completely into contemporary everyday life that it would be experienced as the natural, material expression of an indigenous people, or *Volk*.

Richard Riemerschmid's "Great Step Forward"

A gray stoneware tankard bearing a motif of spiraling, cobalt-stained ivy and designed in 1902 by Munich artist Richard Riemerschmid (1868–1957) for the Westerwald firm of Reinhold Merkelbach, placed the gritty texture of the past into the hands of a modern German *Volk* (Figure 3). In discussing the influence of the vernacular in German design reform, Maiken Umbach has proposed that "on a conceptual level, the notion of the 'vernacular' bound together the two decisive components of this reform project: the tradition of craftsmanship and a sense of geographical 'rootedness' that countered the threatening alienation between people and the material culture of modernity."[12]

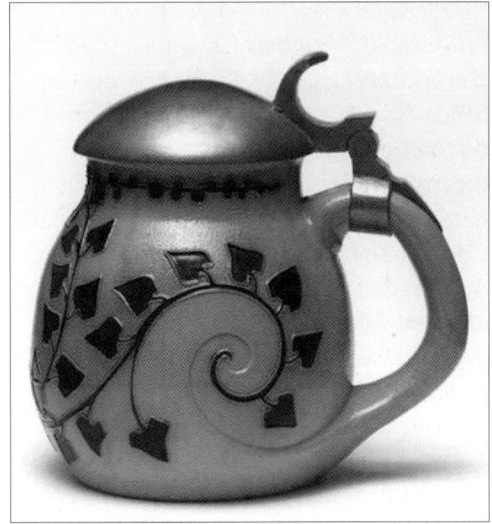

Fig 3 Richard Riemerschmid, *Hedra Helix* tankard designed for Reinhold Merkelbach (tankard model no. 1729), gray stoneware with inlaid cobalt stain, 1902. ©V&A Images/2009 Artists Rights Society (ARS), New York/VG Bild-Kunst, Bonns.

Riemerschmid's salt-glazed beer mug eased its user into modern life by giving him something familiar and concrete—rock-solid—to hold on to. The history of Westerwald stoneware as indigenous resource, geographically specific material, vernacular craft process and utilitarian tradition, adapted by modern designers for cosmopolitan life in the twentieth century, reveals the paradox inherent in shaping a modern German identity. For although the stoneware industry strove toward technological innovation and mass production, it did so in order to recover the Westerwald's lost glory, which—like the clay itself, literally rooted in the German soil—was buried in the past. The Westerwald aspired to what Susan Stewart has termed a "future-past": a utopian state in which the idealized image of a bygone era is resuscitated.[13] But by infusing their modern, reproducible designs with signs of regional handcraft, designers for Westerwald firms not only ensured the survival of craft in the machine age, but also bequeathed its historians material evidence of Wilhelmine Germany's ambivalent engagement with modernity. The vernacular idyll—an idealized vision of a timeless, preindustrial Arcadia distinct and exempt from the recent, historical past of the *Gründerzeit*—was central to the conception of modern German design. Westerwald stoneware's embodiment of this vernacular past helped it to define a modern sense of German "quality."

Ironically, however, the first significant interaction between modern "art" and stoneware "industry" resulted from the Westerwald's collaboration with an artist whose mother tongue was not German. In 1901, the Westerwald District Council applied to the renowned Belgian designer Henry Van de Velde to bring his contemporary sensibility to Westerwald products. Although Van de Velde had had little prior experience with the medium of stoneware, his work was already well known in Germany and greatly admired among its progressive design-reform circles. Just the year before, Van de Velde had been instrumental in an attempt to revitalize Krefeld's struggling silk and dressmaking industries by assuming a commanding role in an exhibition of artist-designed women's reform dresses mounted by Friedrich Deneken, director of Krefeld's Kaiser Wilhelm Museum, in August, 1900.[14] In addition to his celebrated avant-garde interiors, Van de Velde's participation in this public campaign to rejuvenate the native industry of a German manufacturing center suffering at the hands of the French fashion industry aligned him with the nationalist cause of German design reform, making him a highly desirable candidate to update the outdated Westerwald wares.

The success of Van de Velde's first designs for stoneware prompted the District Council to recommend him in 1902 to the Prussian Ministry of Trade in Berlin, which subsequently divided his designs among several of the Westerwald firms for immediate production. The new designs inspired the hope of progress in Kannenbäckerland, presenting the possibility of a fresh approach to its age-old industry and earning Van de Velde the historical title of "catalyst" of the modern Westerwald. In addition to bringing new theories of form to bear upon salt-glazed stoneware through the application of his stylized linear

motifs to traditional blue-and-gray vessels, he received most acclaim for his temporary expansion of the conventional Westerwald glaze palette by using the colorful, high-fired, Asian-inspired glazes—previously seen in German stoneware only on the one-off studio ceramics of 1890s "art potters"—on his decorative vases for the firm of Reinhold Hanke (Figure 4).[15]

At Krefeld, Van de Velde's goal had been the "künstlerische Hebung" (artistic elevation) of the modern woman's dress as an alternative to Paris fashion; rather than rejecting the fashionable dress's history of elegance, Van de Velde had offered fashionable German women sophisticated, artistic dresses, which (he hoped) they would desire in place of conventional Parisian novelties.[16] But Van de Velde's strategy of "artistic elevation" proved more appropriate to Krefeld silks than to Westerwald beer mugs. Despite the new life he injected into tired German stoneware through the fashionable cachet of his colorful, modern vases, Van de Velde's preoccupation with formal concerns blinded him somewhat to the Westerwald's two core values: craft

and utility. Zimmermann wrote in 1903 that Van de Velde's stonewares owed too much to the "international" (i.e. French) influence of art nouveau, but the designs of Munich artist Richard Riemerschmid demonstrated true *Materialschätzung*, an affectionate appreciation for the material.[17]

During the 1890s, Riemerschmid had risen from a local Munich painter to a nationally recognized architect-designer. A founding member of Munich's Vereinigte Werkstätten für Kunst im Handwerk (United Workshops for Art in Handcraft) in 1898, he went on to work under contract for the Dresdner Werkstätten für Handwerkskunst (Dresden Workshops for the Art of Handcraft), exerting a major influence on the company's design program from 1902 onward.[18] Riemerschmid's initial experience with ceramics grew out of his friendships with three colleagues at the Vereinigte Werkstätten, the art potters Theodor Schmutz-Baudiss, Walter Magnussen and Jakob Julius Scharvogel. In 1900, after the success of Riemerschmid's "Room for an Art Lover" at the Paris World's Fair, the Westerwald firm of Reinhold Merkelbach

Fig 4 Henry Van de Velde, salt-glazed stoneware vessels with high-fired polychrome glazes designed for Reinhold Hanke, c. 1902. © The Trustees of the British Museum/2009 Artists Rights Society (ARS), New York/VG Bild-Kunst, Bonns.

approached him to design modern beer vessels, inviting him to visit the manufactory in order to experiment directly with the clay and work with the firm's technicians.[19]

Riemerschmid's close collaboration with Reinhold Merkelbach resulted in a redefinition of craftsmanship for the machine age and the adaptation of the Westerwald's utilitarian vernacular for the modern middle-class consumer. His designs constituted a new conception of stoneware that seemed refreshingly modern compared with nineteenth-century historicist wares, yet restrained and functional in contrast to both individualistic studio art pottery and Van de Velde's undulating vases. Period reviews praised Riemerschmid for expressing the "right feeling" for the tough, dense clay body in simple, sturdy forms. One critic argued that Riemerschmid's stonewares were more successful than his designs in any other material, while another claimed that through his keen understanding of the material itself, Riemerschmid followed "in the footsteps of the old potters."[20]

But Riemerschmid's appreciation for the material went beyond the stoneware clay, to embrace the history of its technology, or craft (Figure 5). His rationalized sphere-and-cylinder construction of a 1903 jug, decorated in a blue-and-gray lozenge pattern, was designed for serial production and also for domestic use. Its broad surfaces and simplified forms were visually "modern," as well as being easy to use and clean. These aspects of Riemerschmid's design contrast starkly with the more complex, ornamented form of a sixteenth-century baluster jug (see Figure 1); however, Riemerschmid's dripping geometry shares more with the sixteenth-century decoration than cobalt pigment. The baluster jug's complicated decorative scheme was achieved by hand through a combination of techniques, including the application of a molded frieze, as well as the stamping, rouletting and incising of the clay surface. During the incising process, known in the Westerwald as the "scratch technique," a sharp tool was used to outline ornaments in the leather-hard clay, after which cobalt oxide was applied within the voided areas. But Riemerschmid's incised lozenges, while they allude to the Westerwald's decorative traditions and convey the sense of time-honored craftsmanship, were far from "handcrafted" in the conventional sense.

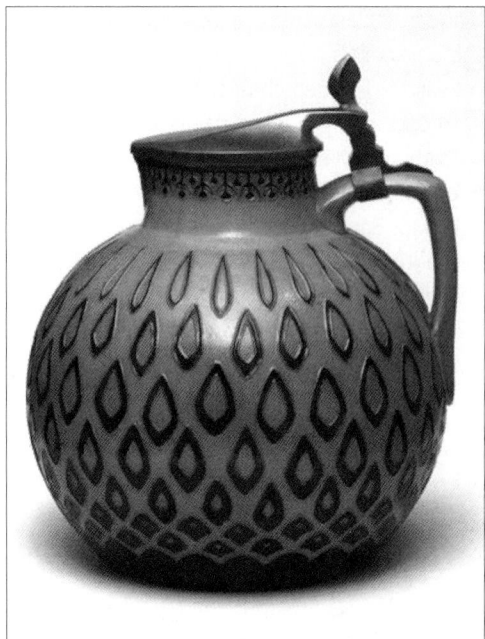

Fig 5 Richard Riemerschmid, jug with lozenge pattern designed for Reinhold Merkelbach (jug model no. 1769), gray stoneware with inlaid cobalt stain, 1903. ©V&A Images/2009 Artists Rights Society (ARS), New York/VG Bild-Kunst, Bonns.

Though initially carved into the body of a model jug, the "scratched" lozenges became reliefs when this original jug was cast to form a hollow mold, within which jug after identical jug could then be thrown. Rather than being painstakingly incised one by one, the lozenges were thus imprinted all at once into the jug's surface as the technician pressed the clay against the mold; the cobalt stain was applied later within the impressions. This serial production process enabled Merkelbach to manufacture hundreds of identical vessels—each one ostensibly unique. Zimmermann immediately hailed Riemerschmid's modernized scratch technique as a "great step forward" in

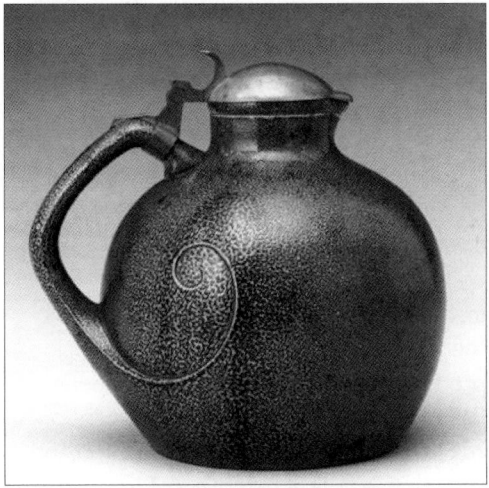

Fig 6 Richard Riemerschmid, jug designed for Reinhold Merkelbach (jug model no. 1729, 1902), executed in gray stoneware with *braun geflammt* [oxidized brown] surface treatment, 1910. Philadelphia Museum of Art: Purchased with the Haney Foundation Fund, the Bloomfield Moore Fund, and the Edgar Viguers Seeler Fund, 1987/2009 Artists Rights Society (ARS), New York/VG Bild-Kunst, Bonns.

its adaptation to "modern mechanized production."[21] By perpetuating the illusion of one-of-a-kind, hand-decorated pottery, while at the same time facilitating a production process in which form and ornament were created simultaneously in one infinitely repeatable step, Riemerschmid's design not only advanced Westerwald technology, but, more significantly, bridged the gap between vernacular craft and the modern demand for reproducible, affordable and hygienic products. His modern stonewares fetishized Westerwald craft within their rationalized, reproducible forms, repackaging regional tradition for a new national market.

Riemerschmid used his "modern scratch" technique to integrate the generous body of a bulbous brown jug with its invitingly rounded handle in a single, powerful spiral incision (Figure 6). This vessel, designed in 1902, performed a second, symbolic integration of traditional craft and modern technology when it was fabricated in 1910 with a speckled brown surface. While Van de Velde had explored arty, "foreign" colored glazes, Riemerschmid became involved in the revival of iron-brown surface treatments, based upon the archaeological study of sixteenth-century stonewares excavated during the 1890s near the ancient Rhineland city of Cologne. Though the Cologne stoneware tradition was historically and geographically distinct from that of the Westerwald, Reinhold Merkelbach capitalized upon its nationalist resonance—particularly as a unique product of the German Renaissance that could be readapted for modern use—in the appropriation and revival of the *kölnisch* stonewares. Shortly after 1905, in their attempts to replicate the surface treatments of the excavated

pieces, technicians at Reinhold Merkelbach "rediscovered" the technique of applying a layer of iron-bearing slip beneath the salt glaze. If exposed to oxygen during firing, the iron particles oxidized and speckles developed in the brown slip. The suggestion of antique patina that the speckles conveyed was achieved, however, through a distinctly modernist approach to surface decoration that relied solely upon the inherent properties and processes of materials, rather than intentionally applied ornament.[22]

In addition to this *braun geflammt* or "oxidized brown" effect, a second rediscovered technique—*kölnisch braun*, or "Cologne brown"—featured cobalt relief ornaments that turned a shiny black when fired under a layer of iron-brown slip (Figure 7). In a process similar to his "modern scratch," Riemerschmid's relief ornaments were again fabricated simultaneously with his vessels. This time, in order to mimic the meticulously handcrafted reliefs on vessels excavated at Cologne, Westerwald technicians pressed cobalt-colored clay into depressed areas of molds before throwing their pots within them; in this way, the cobalt clay adhered to the pot as it was being thrown. After being dipped in brown slip and then fired, these "applied" ornaments turned a glossy black. A review of Riemerschmid's *kölnisch* browns noted reassuringly that "Although the decorations are strictly modern in origin, and used in sparse and striking new ways, they still nestle against the body of the vessel, as the old reliefs did."[23]

The fabrication of these "new" antique browns was hailed as a great technological advance; but here technology was understood not simply as a progressive force, but rather, as a means for reclaiming the lost pinnacle, not only of Westerwald production, but of German achievement. Both Reinhold Merkelbach's appropriation of Cologne's historic, regional tradition and the positive critical reception of the *kölnisch* Renaissance stoneware's adaptation for the modern Westerwald industry, signal the expressly modern attitude to the regional vernacular adopted by a recently unified Germany seeking national cultural currency in the regional riches of its past. While Cologne and the Westerwald had evolved separate stoneware traditions, to early

Fig 7 Richard Riemerschmid, jug from a beer service designed for Reinhold Merkelbach (jug model no. 1758) in 1903, executed in gray stoneware with *kölnisch braun* surface treatment, 1910 (right); tankard from Merkelbach beer service in blue-and-green treatment (left). 2009 Artists Rights Society (ARS), New York/VG Bild-Kunst, Bonns.

twentieth-century eyes, both were time-honored, authentic and indisputably German. In its bid for the status of Germany's preeminent modern stoneware producer, Reinhold Merkelbach amalgamated regional traditions into a consolidated, modern "German vernacular."

This hybrid vernacular was interpreted as being not only newer but *better* than its historical counterparts. The new *kölnisch* browns, according to contemporary glaze chemists, were even richer and more vibrant than their sixteenth-century prototypes.[24] These brown slip-wares, which both referred to and improved upon the long-forgotten pottery of Cologne with the tools, techniques and materials of the Westerwald, became synonymous with Riemerschmid's modern designs for Reinhold Merkelbach between 1905 and 1915.[25] Their enactment of a nostalgia-driven progress exemplifies the Westerwald's complex and cautious approach to modernism. Riemerschmid's "great step forward" was taken "in the footsteps of the old potters," aligning his accomplishment for the Westerwald with Jeffrey Herf's description of Germany's paradoxical "reactionary modernism," in which the development of technology was aggressively promoted and celebrated for its "magical" ability to recreate a faded era in a new-and-improved Technicolor.[26] This "future-past" modernism—busily improving the present in order to reclaim a distant, idealized past—made the Westerwald industry a valuable asset to the nascent Deutscher Werkbund in 1907: its products were practical, tangible examples of how a modern German culture of the everyday—an *Alltagskultur*—might look.

"Quality Work": Westerwald Model and Werkbund Agenda

In their synthesis of tradition and progress, Riemerschmid's new designs adapted both aesthetics and technology for contemporary use. His modern vernacular positioned the Westerwald to serve as a prime example for the Deutscher Werkbund in its campaign to revitalize German culture through the development of modern, "quality" products. Quality (*Qualität*) took on special significance in Werkbund discourse between the organization's 1907 founding and its first major exhibition at Cologne in 1914. Although it would seem simply to imply something well made, the Werkbund used *Qualität* in a more exacting sense, to mark specific products that met its technical and aesthetic standards. Both Werkbund members and cultural scholars have wrestled with the Werkbund's appropriation of *Qualität*, noting a tendency toward abstract, ambiguous jargon. The designer August Endell wrote in 1914 that "The unfortunate word *Qualität* in the Werkbund program" had led to "dire misunderstandings. For 'Quality' means in the end nothing more than to make something well, and that is simply self-evident."[27] Nevertheless, modern Westerwald stoneware was understood by Werkbund members as a quintessentially "quality product." An investigation of its particular physical and ideological properties facilitates a more complex interpretation of the deceptively simple *Qualität*—a term that began with materials and process, but expanded ambitiously to embrace form, culture and commerce. Conversely, an examination of Westerwald *Qualität* enables a more practical, *sachlich* understanding of the Werkbund itself.

Qualität was founded upon the modernist vernacular idyll. To architect, cultural critic and influential Werkbund member Hermann Muthesius, simple vernacular forms, evolved in response to utilitarian needs, were perfectly suited for adaptation to a practical modern lifestyle. In his review of the 1906 Third German Applied Arts Exhibition in Dresden—an event that juxtaposed conventional crafts with modern, artist-designed products fabricated with the aid of machines, galvanizing the progressive *Kunstgewerbewegung* (Art-Industry Movement) and prompting the formal founding of the Werkbund in 1907—Muthesius praised Riemerschmid's modern stonewares, whose forms and functions were derived from vernacular prototypes, which had stood the test of time by transcending the influence of fashion.[28] Muthesius's notion of an unpretentious, ahistorical, "style-less" German material culture that had, he believed, evolved naturally from a primeval vernacular for contemporary use, was central to the concept of *Qualität*: a measurement of inherent worth that outweighed both historical style and commercial value.[29]

Applied arts products labeled as *Qualität* demonstrated the successful evolution of preindustrial regional craft for modern national industry, since *Qualität* began with the material itself. Ernst Berdel, chief glaze chemist at the Westerwald's government-funded Royal Ceramics Technical College in Höhr, equated stoneware with authentic German culture because it "grew out of the ground, which contained the most delectable clay deposits."[30] In his 1907 review of the Dresden exhibition, Muthesius targeted the inappropriate use of materials as the primary cause for "cheap and nasty" products; where indigenous natural resources, such as stoneware, were concerned, the misuse of materials actually squandered the national wealth. The remedy, Muthesius concluded, was for the designer to study the precise *character* of the material, which would, in turn, dictate the best methods of construction and the most suitable forms.[31] His Werkbund colleague, Stuttgart museum director Gustav Pazaurek, characterized Westerwald stoneware as a "beautiful, hard, manly material" that required appropriate handling. While firms that resorted to applying low-fired, colored enamels to their stoneware beer mugs as cheap marketing gimmicks were accused of emasculating stoneware, Riemerschmid and the designers who followed his example were applauded for restoring stoneware to its primal virility.[32]

In 1910, Pazaurek named two slightly younger designers, Albin Müller (1871–1941) and Paul Wynand (1879–1956), as the successors to Riemerschmid's remarkable *Materialschätzung*, or material-appreciation.[33] Under the rubric of *Qualität*, a material's essence could only be expressed through "quality workmanship." Vessels designed by Müller and Wynand met that criterion by furthering the new model of workmanship that Riemerschmid had pioneered between 1900 and 1905. The Magdeburg designer Albin Müller was felt by critics to have achieved a more successful, practical collaboration with many of the stoneware firms than even the "father of the modern Westerwald," Riemerschmid, himself.[34] Müller attended the Magdeburg *Kunstgewerbeschule* (Applied Arts College) in 1900, proceeding to teach interior design there until 1906, when he was invited to join progressive designers, including Josef Maria

Fig 8 Albin Müller, punchbowl designed for Simon Peter Gerz I, gray stoneware with cobalt stain, 1910. © The Trustees of the British Museum.

Olbrich, at the artists' colony in Darmstadt. Müller's contributions to the modern Westerwald were not the first to come from a Darmstadt artist. Peter Behrens (1868–1940), perhaps Müller's most illustrious predecessor at the colony (Behrens had left in 1902 to become the director of the Düsseldorf *Kunstgewerbeschule*), had made a few early designs for the Westerwald firms.[35] Though Behrens's legacy for modern design far surpasses that of his Magdeburg colleague, Müller's impact upon the medium of stoneware was indisputably the more significant. Between 1906 and 1912, Müller worked with over a dozen Westerwald firms, contributing numerous designs to their expanding repertoire of "modern" products.[36]

Raised in a family of carpenters, Müller brought his personal experience with *Handwerk* to bear upon his role as a designer. His designs for the Westerwald firms received high praise for their *Machbarkeit* (technical feasibility), an achievement which Pazaurek believed to be the direct result of Müller's "loving cooperation" with potters and model-makers.[37] Though Müller's interpretation of the *Bowle*, a traditional punchbowl form, revealed the designer's delight in decoration, he outdid even Riemerschmid in his rationalized approach to its application, relegating his interlacing patterns to predetermined bands and panels within broad expanses of the rough, gray surface (Figure 8). Müller approached the clay surface like a woodworker, addressing the facets of his vessels as if they were smooth boards to be carved. But despite the impression of hand carving in leather-hard clay, a wheel-casting process similar to Riemerschmid's, in which the pot was thrown within a carved mold, enabled the simultaneous, standardized fabrication of vessel and ornament; additional cast elements, such as handles and feet, were added later. While this eliminated hours of handwork, it also facilitated the dissemination of a handcrafted "look" to a wide audience, through the manufacture of multiple identical—and affordable—vessels.

Paul Wynand found his way to stoneware not through traditional handcraft but through his training as a sculptor. After studying at the Berlin *Kunstgewerbeschule*, Wynand worked in 1900 with Auguste Rodin in Paris, later teaching at the applied arts school in his home city of Elberfeld (now Wuppertal). In 1905 he joined the faculty at the Westerwald's Royal Ceramics

Fig 9 Paul Wynand, punchbowl designed for Reinhold Merkelbach, gray stoneware with *kölnisch braun* surface treatment, 1911.

Technical College in Höhr, where, in addition to teaching, he worked with Reinhold Merkelbach, continuing Riemerschmid's exploration of the Westerwald's *kölnisch braun* palette with a series of designs featuring black reliefs on speckled brown bodies. Wynand's sculptural vessels, whether architectonic or organic, appeared strikingly modern. Biomorphic, marine-like motifs clung like barnacles to his hefty forms in an intuitive fashion that demonstrated Wynand's *Materialgerechtigkeit*—his "justice" to the material. A speckled brown punchbowl for Reinhold Merkelbach struck a compromise, in the eyes of the stoneware critics, between the "foreign" novelty of Van de Velde and the tried-and-true materials, utilitarian forms and decorative techniques of the old Rhineland potters (Figure 9). In contrast to Riemerschmid's "nested" decorations and Müller's "carved" bands, Wynand's obsidian jewels protrude from the brown surface of his punchbowl as if worked, like exquisite beaded embroidery, into the slick skin of the voluptuous form. These molded reliefs, created as part of the vessel in a single step during the casting process, reinterpreted the delicate *Perldekor*—the ornamental clay pellets applied painstakingly, one by one, to German stonewares from the region of Thuringia during the seventeenth century. This modern, technological translation of a seventeenth-century vernacular convention anchored Wynand's expressive design in Germany's cultural heritage with the weighty substance of stoneware. His complex, yet efficient integration of artistry with industry represented for Berdel "the grand, organic advancement of the truly old. Here the modern and antique triumphantly shake hands, and the character of the heavy, dignified stoneware technique is guaranteed [for modernity] by this artist who works the material with his own hands."[38]

The Werkbund vision of quality workmanship dictated the collaboration of modern art, traditional craft and industrial technology. Though the Werkbund was a diverse body of individuals whose views were frequently in conflict with one another, its basically progressive formal and technological agenda had developed in opposition to the products and practices of the traditional trades.[39] For Muthesius and his supporters, mechanized production was key, not only to the development of modern

forms, but to creating a modern *Alltagskultur* by equipping the middle class with *Qualität* through the mass production of reliable, artistic and affordable products. In the Westerwald, new methods of manufacture celebrated the stoneware industry's legendary achievements: Berdel decreed that the modern forms and decorations generated by serialized, mechanized processes were so "harmonious and organically unified" that he could confidently compare them to the best sixteenth- and seventeenth-century examples. The increase in production resulting from new techniques made these celebratory wares available for everyday use.[40]

The collaboration of progressive designers and technicians at Westerwald firms had effectively replaced both the excessive embellishments of historicism and the undesirable idiosyncrasies of handcraft with standardized, sanitized pottery that spoke at once of heritage and hygiene. A new kind of Westerwald "craftsmanship"—though it rendered the virtuosity of the traditional craftsman obsolete and even borrowed, at times, from the history of other regional traditions—actually strengthened the modern industry's symbolic connection to its vernacular heritage. Through an evolution of the technology already inherent in its craft, the Westerwald had, by 1910, begun to reclaim its lost title of *Qualität*.

Delight in *Sachlichkeit*: Modern Stonewares as Cultural Agents

While *Qualität* derived its critical weight as a marker of an object's inherent value from the belief that all materials possessed an "essential nature," its twin concept of *Sachlichkeit* implied an essential nature, character—or even personality—of form. And just as *Qualität* applied not simply to materials as such, but to materials in action—that is, to process—so the formal implications of *Sachlichkeit*, the ways in which an object's form was understood to express its character, were inseparable from the object's function, or, in *sachlich* terms, from the *purpose* of the *thing*. Period commentators support a reading of *Sachlichkeit* as "thingliness" by linking purpose with personality in their animated descriptions of Riemerschmid's utilitarian objects. In his 1908 account of modern design in Germany, the Austrian art critic and Werkbund member Joseph August Lux wrote that Riemerschmid's objects "act as if they really were individual beings, characters who have their own moods and follow their own rules ... all the housewares are given expressive faces, inspiring droll, gnome-like thoughts ..."[41] Lux's Werkbund colleague, Paul Johannes Rée of the Bavarian Museum of Commerce and Industry in Nuremberg, concurred with this assessment, noting the curious way in which Riemerschmid's things seemed to "affect us like beings who, while they are intended to serve us, do so gladly and willingly, with faces that testify to their inner cheerfulness and freedom." Rée concluded that "die Sache"—the task at hand, or, in this case, the *purpose*—was everything to Riemerschmid.[42]

For Rée, the rough, gritty texture of Riemerschmid's salt-glazed stoneware tankards expressed a "männlicher Biederkeit," or manly honesty, conveying a distinct sense of *Biergemütlichkeit*—beer coziness!—to all who drank from them. But Rée's formulation of "cheerful servitude" seems almost restrained in contrast to Muthesius's

Fig 10 Richard Riemerschmid, *Beer Service* designed for Reinhold Merkelbach 1903, photograph published in *Dekorative Kunst* VII/7 (April 1904), p. 273.

description of Riemerschmid's 1903 *Beer Service* for Reinhold Merkelbach (Figure 10) in an affectionate passage from the April 1904 issue of Munich's applied arts journal, *Dekorative Kunst*: "The little baby tankards offer themselves in an orderly fashion to the loving embrace of the empty hand, while the large jug seems in his [*seiner*] already half-tipping motion, to be just waiting for the moment when he will be next called upon to perform his accommodating service with drink."[43] Somewhat surprising in these modern critics' accounts is the palpable sense of delight in the animated forms that express the individual "thingliness" of Riemerschmid's objects. While one might imagine that Muthesius, an aggressive proponent of standardization in design, would eschew the notion of biomorphic playfulness, his article for *Dekorative Kunst* reveals his inability to contain himself when confronted with Riemeschmid's jocular beer mugs. As serendipitous as they may seem, the exuberant responses of these earnest Werkbund members were hardly coincidental. An animated "quality object," whose *sachliche* form both showcased the essential nature of its materials and enabled it to act out its purpose within the middle-class German home, was the perfect candidate to further the Werkbund's grass-roots agenda.

For Muthesius, Riemerschmid's objects were "kräftige Hausmannskost," or hearty home-cooking.[44] He identified in the Bavarian artist's designs "art in that special, Germanic sense," a craftsmanship and character that were "rooted in the soil [*bodenwüchsig*] ... the art of daily life ..."[45] Riemerschmid's stonewares evoked a folk past, realizing a common ideal of rustic German life through their celebration and animation of everyday utilitarian functions. But his beer service not only recalled preindustrial traditions of making and use: it was also eminently usable in modern life. The conviviality associated with centuries' worth of durable Westerwald stoneware could now be reenacted with updated versions of time-honored vessels. This performative aspect of the new stonewares allowed middle-class Germans to participate in a modern culture indexically connected to a common (if idealized) past, through the material of the clay itself. And it was the clay, in turn, that determined the economic force of *Qualität* as indigenous product, national resource and cultural symbol. According to Karl Ernst Osthaus, director of the German Museum for Art in Trade and Industry in Hagen (a vehicle for Werkbund programs), this "authentic product of the soul" of Germany would rejuvenate its economy.[46] Put more plainly, modern stoneware's potential to combine culture with commerce in a recognizably German product tantalized Werkbund reformers like Muthesius and

Osthaus, who enlisted the modernized Westerwald in their campaign for *Qualität*.

Stoneware's attraction for the Werkbund was due in large part to its reification of a specifically German cultural ideology, or *Kultur*. Much like stoneware, *Kultur* implied an indigenous, inherent Germanness predating and resisting the inhibiting structures of foreign civilization, or *Zivilisation*. While *Zivilisation* came to signify the external imposition of transitory novelties and foreign frivolities—the "tyranny of fashion"— associated with the nineteenth-century rise of industrial capitalism, *Kultur* stood for that which was both innate and enduring in German self-identity. Characterized by intellectual freedom, *Kultur* was reflected and protected by the *Bildungsbürgertum*, or educated middle class.[47] Werkbund reformers capitalized upon the middle-class connotations of *Kultur* in the concept of *Lebenskunst* (life-art), an aestheticization of everyday objects that architectural historian Mark Jarzombek has called the theme of Wilhelmine domestic culture.[48] The fetishizing of everyday life as the heart of all German culture endowed utilitarian objects such as Riemerschmid's stonewares with a moral purpose (in addition to their practical one) as bearers of "Germanness."

Art critic and Werkbund member Karl Scheffler discussed the idea of an *Alltagskunst* and explored the connections between German art and German life in *Moderne Kultur*, a two-volume edited guide to modern domesticity published in 1907.[49] In articles on subjects from kitchen crockery to religion, Scheffler, along with other prominent intellectuals and artists, attempted to synthesize cultural pedagogy into a modern bourgeois ideology. *Moderne Kultur* charged the *Bildungsbürgertum* as the modern stewards of *Kultur*. By educating the middle class about modern *Qualitätsware*, or "quality products," *Moderne Kultur* encouraged discerning consumers to enact practical reforms from the inside out—beginning in the domestic interior and overflowing into public life. Through their purchases, the educated middle class could infuse modernity with Germanness; the acquisition of household items was to be understood not merely as an expression of personal taste, but as an act of cultural allegiance.

Moderne Kultur implied in its title an evolution of German culture for modern life: the preindustrial, spiritual force of *Kultur* would ground the destabilizing aspects of modernity, including industrial capitalism. If a modern German culture was to be disseminated through consumer goods, the problematic ambivalence of the *Bildungsbürgertum* toward modern consumerism had to be counteracted though the stamp of *Kultur*, applied to modern products. The vernacular motif— the tangible sign of handcraft imprinted upon the industrially produced beer mug, for example—representing the values of usefulness, simplicity, authenticity and permanence, was the emblem necessary to redeem consumer capitalism and so harmonize the turbulence of modern life. In its section on ceramics, *Moderne Kultur* applauded the Westerwald's revival of "long-forgotten" techniques and their adaptation to modern products. Like Muthesius, Scheffler championed the work of Riemerschmid, who, he claimed, combated the forces of *Unkultur* with his stoneware vessels for Reinhold Merkelbach.[50] Riemerschmid embraced modernity and, together with Merkelbach,

exploited the potential of technology; but he remained clad in the armor of *Kultur* throughout by allowing stoneware's preindustrial heritage to guide his designs. As early as 1901, Scheffler had discussed the concept of the *Kulturprodukt*—a man-made product (distinct from a "natural gift") whose design had been culturally engineered to inculcate the values of *Kultur* in the modern German *Volk*.[51] By 1910, modern Westerwald stoneware had been dubbed a *Kulturprodukt*: a product whose market value was (or should be) secondary to—and determined by—its cultural value, or *Qualität*.[52]

"The Spiritualization of German Work" and the Evangelizing Object

Stil and *Mode*, or style and fashion, as Frederic J. Schwartz has pointed out, functioned as opposing discursive terms analogous to *Zivilisation* and *Kultur* in the Werkbund's approach to product design and marketing. The sociologist and dress reform advocate Heinrich Pudor exemplified this *Stil/Mode* polarity in his 1910 article "Practical Suggestions for the Achievement of *Qualitätsware*," with the brief, emphatic statement: "Fashion is the transient, Style is the enduring."[53] Viewed in the light of economist Werner Sombart's chapter on "Economy and Fashion" in his seminal *Modern Capitalism* of 1902, fashion signified not only changing styles of dress, but also the experience of social and cultural life as a unique product of the modern economy, including the design of utilitarian objects. Sombart stressed "the frantic speed of changes in Fashion," personifying it as capitalism's "favorite child."[54] It was this fractious Fashion's chaotic shifting of "styles"—all too familiar to Werkbund members from the nineteenth century's parade of historicist idioms and from the more recent absorption of Jugendstil into the stylistic lexicon of industrial mass production—which the Werkbund sought to arrest (or at least circumvent) through the establishment of a unified (and unifying) modern German style, based on vernacular prototypes yet practical for modern life and immune to Fashion's fancies.[55]

This pure and enduring style was to purge the modern economy of its addiction to fashion. The crusade to cleanse industrial capitalism with *Kultur* was expressed in the title of the Werkbund's 1912 Yearbook, *Die Durchgeistigung der deutschen Arbeit*—The Spiritualization of German Work. The yearbooks, produced as the organization's public face, were to function as educational yet practical handbooks for industrialists and retailers; as such, they exemplified the integration of Werkbund theory and practice.[56] In conjunction with didactic articles including Muthesius's landmark assessment of Werkbund achievement, "Where Do We Stand?," in which he proclaimed that German "quality products" must begin to exert an influence on the foreign market, the 1912 Yearbook published lavish photographs of industrially produced *Qualitätsware* endorsed by the Werkbund and featured several pages of Westerwald stonewares including pieces by Riemerschmid, Müller and Wynand.[57]

The most drastic measure in the Werkbund's campaign to spiritualize the German economy in the name of *Qualität* was the *Deutsches Warenbuch*, or German Warebook, a catalog published jointly in 1915 by the Werkbund, the Dürerbund (another cultural reform organization) and

four retail merchants' associations.[58] Although the *Warenbuch* appeared after the outbreak of the First World War, it was planned in 1913 as a catalog of *Wertarbeit* (work of value): exemplary mass-produced goods for household use. The *Warenbuch* was designed to "exert a significant influence on culture in general," since, as the introduction pointed out, "good products advance a people [*Volk*] not only economically, but also morally and artistically."[59] As proof of their *Wert* or *Qualität*, the products selected for the catalog by the Dürerbund-Werkbund Association (but manufactured by various companies) were stamped physically with a *Wertmarke*, or mark of value. This symbol was printed boldly in the catalog's accompanying text, so as to be easily recognized by consumers "in the flesh."

Unlike twenty-first-century catalog shoppers, *Warenbuch* readers were thoroughly schooled in the principles of both technology and taste. The introductory text included a two-page definition of "quality work," a lamentation on cheap products, a warning against the deceptions of fashion or "*Nouveautés*," and a brief education in the principles of mass-produced wares concluding with the assurance that *Qualitätsware* could indeed be fabricated through modern industrial means. Generous sections were devoted to the proper employment of materials and decoration. Finally, each medium was treated individually: its material nature, the techniques of its fabrication, the appropriate strategy for its design and the practical application of these designs in the home, were all systematically addressed.[60] The section devoted to modern ceramics detailed acceptable and unacceptable practices of manufacture.

Stoneware, as one might expect, should confine itself to sturdy, established utilitarian forms and must never attempt to imitate another material, such as wood or metal. The *Warenbuch* implicitly refuted Van de Velde's earlier proposal of a more colorful glaze palette for stoneware by insisting that its "natural" colors were the traditional blue-and-gray, or the revived *kölnisch* browns. But even these restrained glaze colors should not be applied so thickly as to obscure the recognizable presence of the familiar clay body beneath.[61]

At a more profound level, even, than the *Warenbuch*'s exhaustive didactic text, its numerous photographs provide invaluable information about Werkbund-sanctioned *Qualität*. While stonewares by Behrens and Van de Velde (both Werkbund members) are nowhere to be seen, vessels by Müller and Wynand, as well as Riemerschmid's designs for Merkelbach, are generously represented (Figure 11). Wordlessly, Riemerschmid's robust, *sachliche* beer mugs put *Warenbuch* principles into practice. Here *Sachlichkeit* offered an antidote to the seductions and delusions of fashion, as Riemerschmid's mugs bared their essence to the viewer—the way they *looked* was the way they *were*. At a glance, the educated middle-class consumer could understand not only the functional purpose of these mugs, but the materials from which they were made and the tradition to which they referred. *Sachlichkeit* articulated a symbolic yet direct link from visual form to the network of theoretical and material "qualities" embedded in *Qualität*.

While some period critics indicted the *Warenbuch* as an insidious form of advertising by the ostensibly not-for-profit Werkbund, its defenders maintained that its *Sachlichkeit*

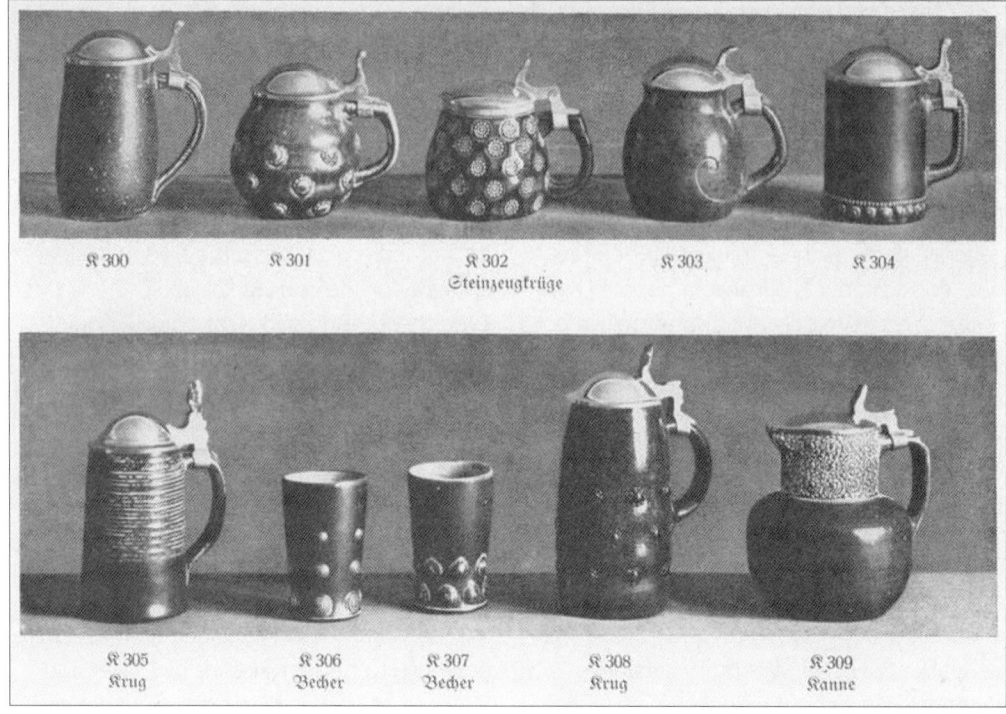

Fig 11 Stoneware tankards including designs by Riemerschmid, Müller and Wynand, published by the Dürerbund-Werkbund Genossenschaft in *Deutsches Warenbuch*, 1915, p. 101. The Metropolitan Museum of Art, The Thomas J. Watson Library Copy Photograph, The Metropolitan Museum of Art.

acted precisely to reclaim capitalism for *Kultur* by stripping the commodity of its guises. The Dürerbund-Werkbund *Wertmarke* was seen by many as nothing more than the Werkbund's "brand"; however, the underlying purpose of the *Wertmarke* was to redeem the brand from fashion, or as Schwartz has argued, to "separate the brand from capital" and restore it to a sign of inherent worth by denoting the actual value of an object rather than its superficial "look." In the pursuit of this goal, the *Warenbuch* traced a second relationship between *Qualität* and *Sachlichkeit* through the visual presentation of its *Wertarbeit*. Schwartz has discussed the *Warenbuch*'s "deadpan" black-and-white photographs of products arranged in orderly rows as a means of transcending capitalist fashion by presenting true quality goods as standardized "types"—objects that had emerged from a process of design evolution as modern examples of established utilitarian predecessors.[62] Printed below the *Warenbuch* photographs was neither the designer's name nor any descriptive caption, but simply the object's "type"—"mug," or "jug," for instance—followed by a serial number. Rather than dazzling consumers with choice, the *Warenbuch* presented them with tasteful, pre-chosen "types": survivors of

the Werkbund's "natural selection" through *Qualität*.

Just as the brand implied the capricious tyranny of Fashion, so the "type" heralded the arrival of the Modern German Style. With the *Warenbuch*'s publication in 1915, the Westerwald's heritage of regional craft had been incorporated into what the Werkbund promoted as a national language of symbolic form, in which the value of a pot could be read on its salt-glazed surface. The "modern-scratch" spiral on Riemerschmid's industrially cast *Warenbuch* "mug no. 303" traced not simply the technical steps from model to mass product, but an evolution of decoration from vernacular craft to modern *Sachlichkeit*, marking, as it did so, the indexical connection between original and replica, in which the hand of the potter became the ghost in the machine.

Baring the German Soul: *Sachlichkeit* on Display

Sachlichkeit was in effect the face of *Qualität*, the immediate, intuitive meaning that modern German products conveyed both at home and abroad. The Modern German Applied Arts Exhibition, organized by Werkbund member and museum director Karl Ernst Osthaus with John Cotton Dana of the Newark Museum, traveled between 1912 and 1913 to seven American cities, disseminating the Werkbund's vision of *moderne Kultur*.[63] Inside a large, unornamented glass virtrine at the Newark Museum, modern stonewares, including vessels by Riemerschmid and Wynand, were arranged in a restrained display akin to their later presentation in the *Warenbuch* (Figure 12). Not only was this clinical parade the Westerwald's first foreign showcase, it constituted a retrospective of the industry's recent rejuvenation, complete with two vessels by Van de Velde.[64] One Newark reporter identified in the stonewares "a strong folk note, not necessarily in its peasant quality, but as a demonstration of the common bond of race … The German finds beauty in vase-forms like truncated cones, in household vessels whose cubes and angles assert themselves, in cups made like sections of a cylinder. These belong to him—something within his soul accepts them as fit."[65] This assessment, made not by a Werkbund ideologue but by an outsider, marks the modern Westerwald's arrival at its longed-for goal. Not only did *Sachlichkeit*'s stark, modern forms impress the American critic, he recognized them as the product of a cultural evolution—the evolution of *Kultur* from regional vernacular to national symbol, implicit in the ascription of *Qualität*.

One of Wynand's stonewares for the American exhibition—an assertive jug with concentric rings accentuating its disk-like body, a conical neck punctuated by a no-nonsense spout, a sharply jutting handle and persistent pointed nubs outlining its radius (Figure 13)—was displayed again at Cologne in 1914 as part of the first comprehensive exhibition of Werkbund-sanctioned design. In conjunction with its segmented, industrially cast body, the jug's antique brown surface treatment corporealized the Werkbund vision of a "future-past." The future of German design, prefigured in this emphatic jug, was understood in the Westerwald as utterly dependent upon its heritage. At the 1914 exhibition, Ernst Berdel declared that: "The industry of Kannenbäckerland will, as it has already done so frequently in the undulating passage of its history, find and fight

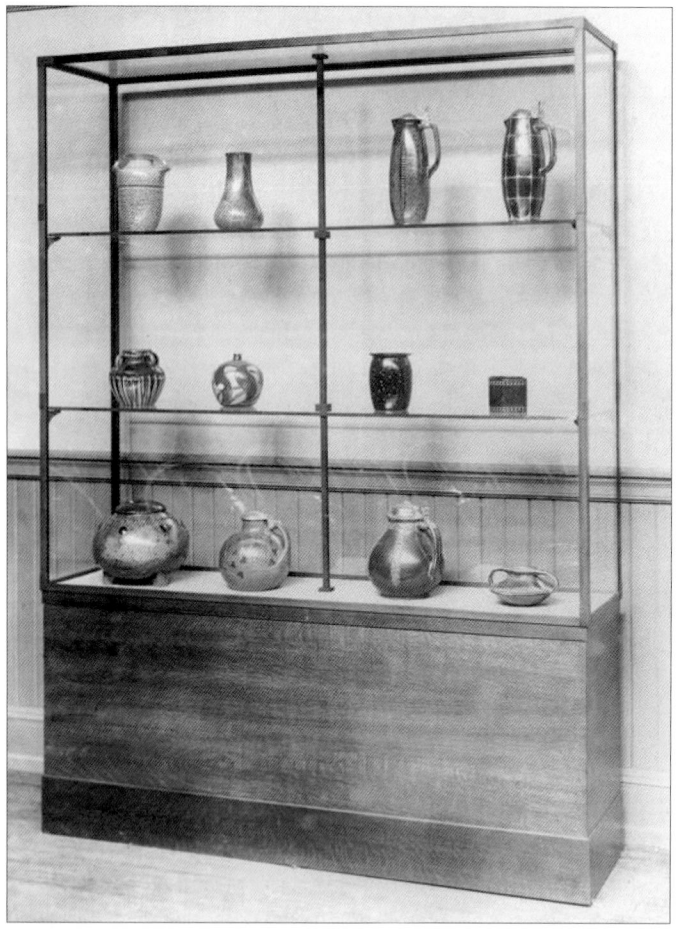

Fig 12 Display of German stonewares including works by Riemerschmid and Wynand at The Modern German Applied Arts Exhibition, Newark, NJ, 1912. Exhibition installation photograph courtesy of The Newark Museum.

for justice with its own strength. It carries the future within itself!"[66] But it was the *designer* who had secured the Westerwald's survival, for it was he who had breathed the ghost of craft into the mechanism of modern industry.

Notes

1 "Der Bierkrug wird und muß immer, mag auch vorübergehend einmal die Mode sich anderswo hinwenden, dem Steinzeug bleiben." Ernst Zimmermann, "Steinzeugkrüge von Richard Riemerschmid," *Kunst und Handwerk* 54 (1903/1904), p. 270.

2 Kannenbäckerland and the entire Westerwald region have since 1946 been part of the Rheinland-Pfalz, or Rhineland-Palatinate, state. The three production centers have since merged into one location known as Höhr-Grenzhausen. See David Gaimster's history of the Westerwald in his comprehensive *German Stoneware, 1200–1900: Archaeology and Cultural History* (London: British Museum Press, 1997), pp. 251–53.

3 Ernst Jaffé, "Neue deutsche Steinzeugkunst," *Kunstindustrie und Kunstgewerbe* 1 (1913), p. 95. Toward the close of the sixteenth century, potters from the villiage of Raeren in present-day Belgium relocated to the Westerwald production center of

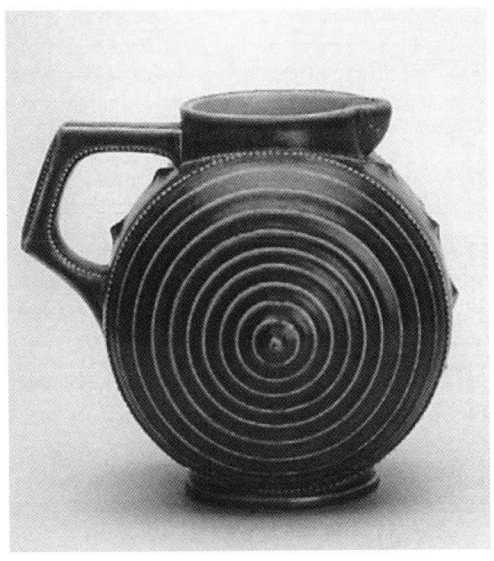

Fig 13 Paul Wynand, stoneware jug with iron-brown surface treatment, 1912.

Grenzau, bringing their expertise and even some of their molds with them; Jan Emens, whose initials are stamped into the baluster jug in Figure 1, was among these immigrant potters. See Gaimster (1997: 224 and 251).

4 For more on Westerwald exports, see Gaimster (1997: 124 and 251).

5 See Gaimster (1997: 252) for a discussion of eighteenth-century Westerwald stoneware.

6 The manufacture of these neo-Renaissance vessels involved the development of a casting process at the firm of Merkelbach & Wick that was a precursor to the more modern, industrial processes developed in the first decade of the twentieth century. See Gaimster (1997: 325).

7 "War es doch schließlich dem Material wie der Herkunft nach die gleiche Ware, wie sie in den billigsten Ramschbasaren herumhing, wie diese gelb-grün-blauen Krüge, bei denen die leichten Zinndeckel immerhin noch das Teuerste waren" Jaffé (1913: 383).

8 Applied arts professor Ernst Zimmermann used this phrase to describe the Westerwald's situation in his article "Die künstlerische Nothlage der Westerwälder Steinzeugindustrie," *Kunst und Handwerk* 50 (1899/1900): 76–83.

9 The application of low-fired enamels (commonly found on porcelain and ubiquitous on low-fired ceramics, or earthenware) was not perceived as "natural" to the stoneware process, since it necessitated an additional step or "afterthought" following the glaze firing. In this sense, applying enamels to stoneware was felt to be a kind of cheapening or adulteration of its inherent material qualities and processes.

10 Streiter first used the word *Sachlichkeit* to refer to this new "realist" agenda for architecture and design in the "Aus München" section of the Berlin journal *Pan* II/3 (1896), p. 249. For an in-depth discussion of Streiter's concept of *Sachlichkeit* and its influence see Harry Francis Mallgrave, "From Realism to *Sachlichkeit*: The Polemics of Modernity in the 1890s," in Mallgrave, ed., *Otto Wagner: Reflections on the Raiment of Modernity* (Santa Monica, CA: Getty Center for Arts and Humanities, 1993), pp. 281–321.

11 "Die keramischen Versuche, welche in letzter Zeit in fast allen bedeutenden Kulturländern Europas unternommen sind, leiden daran, daß sie zu wenig an die thatsächlich [sic] bestehenden, aus Geschichte und Bodenbeschaffenheit resultierenden keramischen Verhältnisse der betreffenden Länder angeknüpft haben." Zimmermann (1899/1900: 76).

12 Maiken Umbach, "The Deutscher Werkbund and Modern Vernaculars," in *Vernacular Modernism: Heimat, Globalization and the Built Environment*, Maiken Umbach and Bernd Hüppauf, eds. (Stanford, CA: Stanford University Press, 2005), p. 124.

13 See Susan Stewart's discussion of nostalgia and the "future-past" in *On Longing: Narratives of the Miniature, the Gigantic, the Souvenir, the Collection* (Durham, NC and London: Duke University Press, 1993), pp. 14–24.

14 This exhibition is treated in the second chapter of my doctoral dissertation, "Delight in *Sachlichkeit*: Richard Riemerschmid and the Thingliness of Things." For further published information on the Krefeld exhibition and Van de Velde's role in it, see Radu Stern, "Henry van de Velde and Germany," in *Against Fashion: Clothing as Art* (Cambridge, MA: MIT Press, 2004), pp. 11–22 and Brigitte Stamm's section on "Künstlerische Reformkleidung in Deutschland: Ausstellungen" in *Das Reformkleid in Deutschland* (Berlin: Technische Universität Berlin, 1976), pp. 51–93.

15 Gaimster (1997: 330–31).

16 See Van de Velde's opening address at the Krefeld exhibition, later published as a pamphlet called "Die künstlerische Hebung der Frauentracht" (The Artistic Elevation of Women's Costume) (Krefeld: 1900).

17 Zimmermann (1903/4: 269).

18 In 1907 (the year of the Deutscher Werkbund's founding) the Dresdner Werkstätten simplified its name and expanded its ambition to become "Die Deutsche Werkstätten."

19 Beate Dry-von Zezschwitz, "Vorbemerkung zu Riemerschmids Keramischen Arbeiten," in *Richard Riemerschmid: Vom Jugendstil zum Werkbund*, Winfried Nerdinger, ed. (München: Prestel-Verlag, 1982), p. 313.

20 "Ein Künstler wie Riemerschmid, der seine Gestaltungskraft an allen möglichen Materialien mit Gelingen erprobt hat, dürfte kaum in einem anderen soviel Glück haben wie gerade im Steinzeug." Jaffé (1913: 384); H. H., "Die keramische Ausstellung im Berliner Kunstgewerbemuseum," *Keramische Monatshefte* 7 (1907), p. 148.

21 "Die alte Ritztechnik aber, d. h. das Umziehen der Ornamente durch eingeritzte Linien, zwischen die dann kobalt-blaue Farbe gelegt wurde, ist so der modernen Mechanik angepaßt worden, daß, um das jedesmalige Ritzen an den Gegenständen selber zu vermeiden, die Linien breit in die Hohlform gedrückt worden sind, so daß sie nachher beim geformten Gegenstande als erhöhte Stege erscheinen, zwischen die dann mit Leichtigkeit die Farbe gelegt werden kann … eine höchst einfache Technik … die einen ganz gewaltigen Fortschritt bedeutet" (Zimmermann 1903/4: 270).

22 For more on these archaeological finds at Cologne see Gaimster (1997: 326).

23 H. H., "Die keramische Ausstellung im Berliner Kunstgewerbemuseum," pp. 146–48, translated in Kathryn Bloom Hiesinger, *Art Nouveau in Munich: Masters of Jugendstil* (Munich: Prestel Verlag, 1988), p. 123.

24 For a period perspective on the development of the antique brown surface treatments see Westerwald glaze chemist Ernst Berdel's article "Die Moderne Entwickelung der Westerwälder Industrie," *Sprechsaal* 45 (1912): 83–85 and 99–101.

25 Gaimster (1997: 326).

26 Herf's concept of a "reactionary modernism" is conceived in relation to the Weimar era and the Third Reich, but I find it useful in analyzing the late Wilhelmine period as well, especially in relation to the decade leading up to the First World War. See Herf, *Reactionary Modernism: Technology, Culture and Politics in Weimar and the Third Reich* (Cambridge: Cambridge University Press, 1984).

27 Endell is quoted in *Die Werkbund-Arbeit der Zukunft und Aussprache darüber. 7. Jahres Versammlung des Deutschen Werkbundes vom 2. bis 6. Juli in Köln* (Jena: Eugen Diedrichs, 1914), pp. 57–58 and translated by Frederic J. Schwartz in *The Werkbund: Design Theory and Mass Culture before the First World War* (New Haven, CT and London: Yale University Press, 1996), p. 122.

28 Muthesius's passionate review of the Dresden exhibition, in a lecture entitled "The Significance of Applied Art," printed in a 1907 issue of *Dekorative Kunst*, denounced the shoddy production methods and application of historicist styles in German industrial production, as well as the reactionary stubbornness evident in the forms and fabrication methods of conventional craft, both of which, he argued, failed to express

the spirit of the modern age. His attacks on the fabrication and aesthetics of German products laid the foundations for the Werkbund debate regarding the implications of *Qualität*. See Hermann Muthesius, "Die Bedeutung des Kunstgewerbes," *Dekorative Kunst* 10 (1907): pp. 177–92.

29 This line of reasoning is most familiar to architectural history from Muthesius's concept of *Typisierung*—the standardization of product design based on long-standing models or "types," whose utilitarian purpose dictated the modern product's appearance—proposed in his "Theses" of 1914 and reprinted in Ulrich Conrads, *Programs and Manifestos on 20th-Century Architecture* (Cambridge, MA: MIT Press, 1986), pp. 28–29.

30 The Königliche Keramische Hochschule had been established in the production center of Höhr in 1876 by the Prussian government to spur the modern development of the Westerwald industry. See Berdel (1912: 83).

31 Muthesius (1907: 76–82).

32 Gustav E. Pazaurek, director of the Königliches Landesgewerbemuseum in Stuttgart, lamented the improper handling of stoneware in the first decade of the twentieth century, including the use of inferior clay bodies and colorful, low-fired enamels as cheap marketing gimmicks. He writes, "Schade um das schöne, harte, männliche Material!" in "Neues Steinzeug von Albin Müller," *Die Kunst* 24 (1910/11): 178.

33 Gustav Pazaurek, "Neue Trinkgefäsze," *Die Kunst* 22 (1910): 174.

34 "Auch der tüchtige Münchener Riemerschmid, dem wir einige der besten Steinzeugkrüge der Gegenwart verdanken, konnte nicht alle Schwierigkeiten beheben. Erst Albin Müller … schaffte dadurch Wandel, daß er in persönliche Verbindung mit der Westerwälder Industrie trat und sich von dem Möglichkeiten zu den Notwendigkeiten führen ließ." Otto Pelka, *Keramik der Neuzeit* (Leipzig: 1924), p. 116. See also Ulrich Plöger and Jürgen Schimanski, *Die Neue Ära, 1900–1930: Westerwälder Steinzeug,*

Jugendstil und Werkbund (Düsseldorf: Contur-Verlag, 1987), p. 16.

35 Gaimster (1997: 331). The survival of some of Behrens's stonewares is likely a testament to his prominence as a modern designer, rather than an indicator of the reception of his stoneware vessels during the period in which they were produced.

36 While Müller, like Riemerschmid, designed prolifically for Reinhold Merkelbach, he also collaborated with a number of other firms (including Simon Peter Gerz I, Reinhold Hanke, Marzi & Remi and Roßkopf & Gerz) to the extent that he was credited by the British *Studio Yearbook* of 1914 with reviving "the potter's art as a domestic industry in the villages of the district [the Westerwald], where it had once flourished." See L. Deubner, "German Architecture and Decoration," *The Studio Yearbook of Decorative Art* (1914), p. 96. Useful timelines of the careers of many important stoneware designers can be found in Plöger and Schimanski (1987: 17–21).

37 "Nur … durch das liebevolle Zusammenarbeiten des Künstlers mit den Drehern und Modellieren in den verschiedenen Werkstätten … wurde in verhältnismäßig sehr kurzer Zeit der überraschende Erfolg erzielt …" Pazaurek (1910/11: 181).

38 "Mit am glücklichsten in neuen Formen sind die Krüge von Simon Peter Gerz I nach Entwürfen von Wynand, eine prachtvolle organische Weiterentwickelung des wirklich alten. Moderne und Antike reichen sich hier erfolgreich die Hand, und der Charakter der wuchtigen, gediegenen Steinzeugtechnik ist von diesem Künstler, der eben mit eigener Hand in dem Werkstoff arbeitet und die ganze technische Seite der Sache voll erfaßt hat, in treffender Weise gewahrt." Ernst Berdel, "Die Tonindustrie im Westerwald," *Keramische Rundschau* (1909), p. 420.

39 The most notable example of conflict within the Werkbund was the 1914 debate over standardization versus individualism in design,

A Catalan Werkstätte? Arts and Crafts Schools between *Modernisme* and *Noucentisme*

Jordi Falgàs

Jordi Falgàs is the director of the Fundació Rafael Masó in Girona (Spain) and a Ph.D. candidate in the Art History program at the University of Wisconsin-Madison. As an art historian he specializes in early twentieth-century art and architecture in Catalonia. He was Cleveland Fellow in Modern Art at the Cleveland Museum of Art (2004–7), where he co-curated "Barcelona and Modernity: Picasso, Gaudí, Miró, Dalí", and assistant executive manager at the Fundació Gala-Salvador Dalí (1996–2003). He has recently edited the book *El Palau de la Música Catalana* (Triangle, 2009).

Abstract

One of the features of Catalan *modernisme* is the blend of vernacular crafts with structural and formal innovations, as found in the work of architects such as Antoni Gaudí and Lluís Domènech i Montaner. In the 1880s, they galvanized a generation of craftsmen and stimulated the establishment of new workshops, but were nonetheless dissatisfied by the lack of a formal education oriented toward these trades. Although Barcelona did eventually gain a School of Arts and Crafts, during the *Noucentista* years the architect Rafael Masó was still hindered in his attempt to create a "very modern" school based on a model of the Deutsche Werkstätten. The development of modern craft in Catalonia was carried out in spite of several failed or interrupted attempts at establishing an arts and crafts school system. Two generations of Catalan artists and architects were involved in this struggle, and as with other European nations at this time, their attempts were shaped by conflicting social and political agendas.

Keywords: Gaudí, Masó, *Modernisme*, *Noucentisme*, Catalonia, Barcelona, Girona, Werkstätte

In November 1887, two architects took a train south to Manises, a small town outside València. Their names were Antoni Gaudí (1852–1926) and Lluís Domènech i Montaner (1849–1923). Like just about everyone else in Barcelona, they were both working against the clock on projects for the upcoming Universal Exposition of 1888. Why would these two young and promising architects travel over 350 kilometers to a derelict pottery center in Spain? Production of Manises tin-glazed earthenware had once been famous, but by then had been in decline for over a century. Yet Domènech still hoped to find and learn "the old traditions of the València potters which were preserved by Casany, an old farmer in Manises" (1903: n.p.).

This trip has a special significance because it exemplifies not only the architects' role in the preservation and flourishing of crafts in and around Barcelona at the turn of the century, but also the quixotic and ultimately unsuccessful attempts to establish a school system or craft organization in which not only pottery, but all vernacular crafts, could be taught and developed in conjunction with architecture and interior decoration. The tension created by the demand for skillfully trained craftsmen was most obvious during the early years of *Noucentisme* (1906–17), when for the first time Catalan public officials, artisans and architects joined efforts toward the reform of crafts.

To understand Domènech and Gaudí's decision to travel to Manises, we need to go six years further back, when the latter wrote a two-part review of the "Barcelona Decorative Arts Exhibition" of 1880. This article, one of the few texts Gaudí ever published, is a precious testimony to his early understanding of craftsmanship and his approach to the role of craftwork applied to architecture.[1] His words are worth quoting at some length:

> The exhibited objects are those of the manufacturer's typical production, which would please us very much if those had the qualities that are to be desired and each manufacturer should hurry to offer them. The exhibited objects are all finely executed, but they do not distinguish themselves by an idea that makes that execution shine. In terms of ideas there are many imitations of the old-fashioned French industry, in which, to avoid being told that they are copies, such disgraceful modifications are introduced that they lose the overall quality, if they had any. Obviously, as a result, tasteless objects come out without any ideas, neither ornamental, nor representational, nor coloristic; and they are left without that nice coquetry of the sumptuary objects known as taste, which can equally be found in the more modest as well as in the richest. This lack of ideas, that we feel obliged to record [to make known] in order to try to find a remedy, is quite notable and deserves a very special attention. (1881: 709–10)

Gaudí also asked for a change in the curricula of art schools. He was certain that a shift toward the design of objects, based on the study of historical models and "working conditions at the time of creation," would

benefit manufacturers as long as these products had "the appropriate shape in accordance with their use and materials." After these preliminary remarks, he provided a detailed review of each section of the exhibition: textiles, embroidery, furniture ("almost all of it has a vulgar shape and style"), metals, ceramics and typography, showing that his critique was based on a profound knowledge of history, collectors, manufacturers, techniques and materials.

Domènech and Gaudí explained their theories not only in writing but also in their buildings and designs. In his pioneering 1963 study, Alexandre Cirici wrote that "When Gaudí set the ball rolling, with the Casa Vicens, he did so on the basis of a rediscovery of Islamic styles which came to mean for Gaudí what the discovery of the Medieval meant for Ruskin" (1963: 23). This is borne out in the use of exposed brick and glazed ceramics on the exterior of the Vicens House (Figure 1), but with an important exception: Cirici dated the construction five years too early and thus mistakenly gave Gaudí the role of predecessor to Domènech's contributions, while in fact it was the other way around. Domènech's project for the Montaner y Simón publishing house, which Cirici dated two years too late, was actually an earlier example of architecture that prominently featured vernacular craftwork, most notably

Fig 1 Antoni Gaudí, Vicens House, detail of the façade's corner with an open cupola, Barcelona, 1883–88. Photograph by Pere Vivas/ Triangle Postals.

in iron, brick, wood and glass (Figure 2). Cirici was correct, though, when he asserted that Domènech and Gaudí's new features were immediately employed by other architects in Barcelona, for instance, Josep Fontseré, Josep Domènech i Estapà and Josep Vilaseca.

Ildefons Cerdà's 1859 plan for the expansion of Barcelona, followed by the completion of the demolition of the medieval walls around the old city in 1868, gave the Catalan capital the opportunity to more than double in size before the end of the century. Industrialization was also rapid and, while a new working class moved from the rural areas and established itself in the old city, the middle class shifted the city center toward the Eixample (the Expansion). Although they established their new factories, businesses and residential buildings there, Cerdà's utopian design of an egalitarian grid for Barcelona's expansion was not welcomed by these bourgeois settlers. In fact, the new Catalan upper middle class was interested in showing how different and unique each one of their new constructions was, and in 1891 the city passed new regulations that allowed greater freedom in the decoration of façades. Façade balustrades gave way to a wide variety of roof terminations, including turrets, open pavilions or crests of various kinds (Freixa and Molet 2007: 237). This facilitated a compositional freedom that gave increasing importance to decorative elements—*modernisme* was born. Now, not only the architects were in demand; skilled craftsmen were commissioned to design façade ornaments as well as lavishly decorated interiors and furnishings. Vidal, Escofet, Rigalt, Pujol i Bausis, Homar, Busquets, Oñós, Casas i Bardés and Cardellach are only a few of a much longer list of these figures.[2] Following their patrons, they also moved the traditional small, guild-oriented workshops from the old city to larger premises in the

Fig 2 Lluís Domènech i Montaner, Editorial Montaner y Simón (currently the Antoni Tàpies Foundation), Barcelona, 1879–85. Photograph by Pere Vivas/Triangle Postals.

architects' dissatisfaction with the city's craftsmen, both buildings are prime examples of *modernisme*'s artisanally made, intricate ornaments and functional elements, as well as finely crafted furnishings. The 1888 Universal Exposition was not the turning point its organizers had envisioned, but by the time art nouveau had reached its height with the Paris Universal Exposition of 1900, Barcelona's workshops of *ébénistes* and decorators alike were humming with activity. They were producing work both to their own designs and on commission from architects and artists. *Modernisme* shaped a new concept of craft and interior decoration that was a definite departure from the productions of the past. Even though it never acquired the status of national art and was only adopted by a segment of the

Fig 3 Lluís Domènech i Montaner, Detail of the lantern atop the Homage Tower of the Universal Exposition's Cafè-Restaurant, Barcelona, completed in 1892. Photograph by Pere Vivas/Triangle Postals.

Fig 4 Antoni Gaudí, design, with Joan Oñós, blacksmith, Detail of the gate's wrought iron, Güell Palace, Barcelona, 1886–88. Photograph by Pere Vivas/Triangle Postals.

Eixample, where there would also be room for machines.

At the time of their trip to Manises in 1887, Domènech was working on the café-restaurant (Figure 3) for the Universal Exposition and Gaudí on the Güell Palace (Figure 4), a modern palazzo in the old town that his patron wanted to see completed on time for the fair's opening. Despite the

upper middle class, *modernisme* provided a generation of craftsmen with a renewed consciousness of unity across specialties. In 1903 this sense of solidarity coalesced in the establishment of the Foment de les Arts Decoratives (FAD), a professional association still active today. In theory, the FAD was supposed to become an equivalent of the Deutscher Werkbund but, as Galí explains, during the first two decades of existence its activity was "meager" and its influence insignificant. It was not until 1922 that the FAD would become an active and productive association (Galí 1982: 181–94).

The Work of *Noucentisme*
On June 28, 1906 the young philosopher Eugeni d'Ors (1881–1954) came up with two new words in his daily column for the newspaper *La Veu de Catalunya*. The first was *noucentisme* ("nine-hundreds-ism"), coined in opposition to *vuitcentisme* ("eight-hundreds-ism") and, as Xavier Pla has noted, it contained a clever ambiguity that allowed the writer to refer both to the number nine (*nou* in Catalan) of the new century and to the adjective *nou* (new) (1996: xvii). "The work of *noucentisme* in Catalonia is—or better yet: shall be—civic-minded (*civilista*) work," Ors wrote. The locus of *noucentisme* would be the idea of Barcelona as a modern city and Catalonia as a modern nation (Ors 1996: 169).

Since 1900 the Lliga Regionalista, the conservative and nationalist party of the Catalan middle class, had gradually become the leading political force in the region. In 1913 it was able to create a consensus with other parties to request from the central government in Madrid the establishment of the Mancomunitat. This was the first administrative recognition of Catalan unity since 1714. The stability that characterized the creation of the Mancomunitat in 1914 and its work until Primo de Rivera's coup of 1923, contrasted with the political instability of this period in Catalonia and elsewhere in Spain, which was marked by social conflict and violence, particularly from 1917 onward.[3]

Noucentisme evolved under the Lliga's ideology and inspired the programs implemented by the Mancomunitat and other local and regional administrations. For the first time in modern Spain, the *noucentista* project—in which the modern city would rise as a new Arcadia—called for a unanimous collaboration between all social bodies. The artist had a special and fundamental role: to give shape to the myth. As opposed to the individualist *modernistes*, *noucentista* artists had a "duty" to be, according to one of the movement's theorists, "the ideal builders of the city and must feel deep in their soul this duty with enthusiasm" (Aragay 2004: 91). Thus *noucentista* institutions promoted large projects of public architecture based on an ideal of public beauty, with special emphasis on mural painting, public sculpture, public gardens and handicrafts applied to architecture and urban planning, such as stuccowork, ceramics and terracotta. In *noucentista*, artist and craftsman were as close as they had ever been in modern Spain, both in the creative process and in the definition of their joint role within society.

This principle of collaboration is closely connected to another fundamental trend of *noucentista* politics. As noted by Peran, Suàrez and Vidal, the most visible aspect

of the movement was probably the effort to accomplish progress through the institutionalization of culture and education (1994: 26). The creation of new schools of all levels, public libraries (the earliest in Spain), museums and other cultural and scientific entities became a priority, initially for city councils and later for the Mancomunitat. *Noucentisme*'s demand for civic-minded art and urban embellishment, combined with the educational effort promoted by the Catalan industrial and commercial bourgeoisie, led to a renewed interest in the education of craft. Eugeni d'Ors and the art historian, critic and professor Joaquim Folch i Torres (1886–1963) were the main theorists and promoters, but between 1910 and 1915 they were joined by writers, critics, historians and artists who published numerous articles devoted to "Praising Craft" (1914: n.p.).[4] Ors had great admiration for the life and writings of French sixteenth-century potter Bernard de Palissy and would declare him a "hero Craftsman," a model of tenacity and abnegation for his dedication to discovering the secret of Chinese porcelain. One of Ors's columns, published in April 1910, was entitled "Too Much":

> There is too much painting. There is too much sculpture. The quantity of contemporary artistic production is monstrously excessive …
>
> In the meantime our forks, our glasses, our curtains, our carpets, our bindings, our books, are created by cold manufacture dealers, without any sparkle of art or spirit. In the meantime our daily life is immersed in banality and ugliness.
>
> Our life will not enter into a period of true aesthetic restoration until nineteen of the twentieth parts of our current artists become craftsmen … —And when I say craftsmen, I do not mean the terrible decorators that we usually suffer today, horrifying fantasies, inventors of incongruities, individualists, pitiful; I mean, men of trade, school, tradition. (2003: 517–18)

Though he was making a similar claim to the one Gaudí had made twenty-five years earlier, Ors could not hide his abhorrence of *modernisme*. He would repeat and develop his convictions for several years, often writing in the first-person plural about the *noucentistes*' "love of craft," for the "work well done," and even "the Holiness of Crafts" (2005: 421–22). It was also an attempt to reverse the roles traditionally assigned to high and low culture and bring together the fine and the folk arts. As he wrote in 1910, it was now time for "intellectual workers" like himself to learn from craftsmen:

> The cause of "the spirituality of trades," for which we battle and in which we have taken Bernard Palissy as our patron, is marching toward victory; on the other hand, it is in the school of handicrafts where the intellectual workers can learn the workers' essential virtues, which will do great good to them: perseverance, order in the efforts, everyday life, discipline, cooperation, modesty and sense of measure and Taste as well. (2003: 512)

One of the first artists to follow Ors's dictum was the Uruguayan painter Joaquín Torres García (1874–1949), whose Catalan father had brought his family to Barcelona in 1891. In 1913 Torres García established the

Escola de Decoració, a first attempt at an arts and crafts school, but it lasted only until 1915. Despite its short history, the school published a single issue of a journal, the *Revista de la Escola de Decoració* and brought together a group of artists and craftsmen who would later contribute to many of the Mancomunitat's public projects and schools.

Enric Prat de la Riba—the leader of the Lliga, who in 1914 became the Mancomunitat's first president—insisted on the need for a large center for higher education in which "to educate our industrials and craftsmen of all kinds, both the professions where man's skill is everything and those where the machine is everything; and to teach them the technical skills, the scientific background of trades and industries and the artistic knowledge and good taste to be applied to each specialty" (2000: 647). Based on these principles, the Escola Industrial that had been established in 1906 was slowly transformed into what became known as the Universitat Industrial, Barcelona's first polytechnic campus. Because Catalonia was one of Europe's most important centers for textile manufacturing, one of the first schools to open was the School of Textile Industries in 1910.

The project to reform art schools in Spain was almost as old as the schools themselves; Royal Decrees with subsequent changes and updates had been issued in 1849, 1900, 1907 and twice in 1910. The result was a confusing and disorganized division between Schools of Industrial Arts and Schools of Industries, each one of them offering elementary and higher degrees. Depending on the size of the city, the number of students, faculty and the school's curriculum—in small towns, if necessary, they could be recombined into a single School of Industrial Arts and Industries. The latest reforms had established that Schools of Arts and Trades would grant an elementary degree aimed at the technical education of workers and craftsmen. This qualification, in turn, would be required for enrollment in the superior degree program offered by the industrial schools.

At Barcelona's Universitat Industrial, great effort was invested in the creation of the new Escola Superior dels Bells Oficis (High School of Fine Crafts). The school's program was approved in 1914 and classes began in the fall of 1915. The curriculum was partially inspired by London's Royal College of Art, with a strong emphasis on the provision of highly specialized, professional instruction around six areas: ceramics, wood, metal, textiles and leather, the garden and architectural sculpture.[5] But the school's officials soon realized that it was not enough to educate students at a graduate level; they had to attend to the craftsmen who were already working in those industries. Therefore, in 1918, the Escola Tècnica d'Oficis d'Art (Technical School of Art Crafts) was established in connection with the High School. The Technical School aimed at craftsmen who had a daily job, so classes were taught in the evening. To enroll, students were only required to be thirteen years old and have basic reading and writing skills. After a common introductory year, the curriculum was divided into four specialties: cabinetmaking, jewelry and silversmithing, wood carving and embossing and chiseling.

Joaquim Folch i Torres was responsible for the Escola Superior's program and curriculum, together with Francesc d'Assís

Galí (1880–1965), a painter who had established a private fine arts academy in 1902 and acquired a great reputation among Barcelona artists—including the young Joan Miró—for his unconventional teaching methods. Because of his experience Galí became the school's director and some of his former students were chosen as professors. In June 1914 he promoted the "Manifest de El Gremi de les Arts Aplicades" (Manifesto of the Applied Arts Guild), which declared:

> Our goal is the embellishment of the city and our works shall provide her with new furniture worthy of our traditions, of her own ceramics, of tasteful textiles, of good stamped embossing, of books as good to see as they are to read, of beautiful mural paintings, of fine glasses, of great buildings and gardens where plastic beauty manifests itself. (1914: n.p.)

While Galí brought his teaching experience, Folch contributed the insights gained from years of studying vernacular crafts and, most significantly, an extensive recent research trip to European museums. Between September 1913 and March 1914 he visited institutions in France, Germany, the Austro-Hungarian Empire, Belgium, England and Italy. He was particularly impressed by the methods and resources at London's Royal College of Art and the advantage provided by its proximity to the Victoria and Albert Museum.

Despite its limited resources and short-lived history—it closed soon after Primo de Rivera's coup in 1923—the Escola Superior set up a model for those created in the 1930s during Spain's Second Republic. In his history of the school, Alexandre Galí wrote that eight years "are nothing to resuscitate a people's art or leave new signs on its physiognomy," but also noted that the instutution had become a model for other art schools outside Barcelona (1982: 53). These "second cities," as they were named by Ors (1996: 212), were Terrassa, Girona, Sabadell, Vilanova, Sitges and Manresa and there were also a series of even smaller towns where the Mancomunitat provided support for the so-called "Minor" schools of fine arts or arts and crafts, mostly located in the Girona region: Olot, Sant Feliu de Guíxols, Palafrugell, La Bisbal, Llagostera and Puigcerdà.[6]

Rafael Masó's Project in Girona

In 1900 Girona (pop. 16,918) was a small town compared to Barcelona (pop. 533,000), but thanks to the architect Rafael Masó i Valentí (1880–1935) it acquired a significant role in the history of *noucentisme* and, in particular, in the renewal of interest in the role of craftsmen. Girona was a provincial city with a localized, rural economic base and apprenticeship and work patterns in its handicraft workshops had changed little since preindustrial times. But the city's role as administrative capital for the surrounding region allowed for a small bourgeoisie—conservative and profoundly Catholic—and it was into this class that Rafael Masó was born. Between 1900 and 1906, he was a student at the Barcelona School of Architecture, where one of his professors was Lluís Domènech i Montaner. During these school years Masó was carried away by Gaudí's work and ideas, not only in formal terms but also by their religious and social significance. According to Tarrús and Comadira, it is *Gaudinisme*—Gaudí's unique blend of religion, nationalism and history in architecture—rather than *modernisme* as a whole, that Masó had

Fig 9 Rafael Masó, design, with Joan B. Coromina, ceramist, *Tiles from the Escola d'Arts i Oficis*, 1916. White, red and brown engobe, oxides and varnish; 20 × 20 × 2 cm (each tile). Centre Cultural de Caixa Girona, Girona. Photograph by Jordi Puig.

traditional ceramics.[14] As he had done with the pharmacy jars, he intepreted a traditional and popular theme in Catalan pottery for its use in a modern building. I have also found an unpublished Masó design for the School of Arts and Crafts (Figure 10). It is a watercolor for two coats of arms to be produced in stained glass, one with the Cross of St. George (or St. Jordi, the patron saint of Catalonia) and the other with the coat of arms of Catalonia. Masó frequently designed stained glass for his buildings—always to be manufactured by Antoni Rigalt in Barcelona—but it appears that these and a few other ornaments he had sketched never left the architect's drawing table because of the school's interrupted construction.

Scholarship has hitherto attributed this failure exclusively to local politics, but I would like to consider a wider perspective to

Fig 10 Rafael Masó, *Design for a Stained Glass with the Coats of Arms of St. George and Catalonia for the Escola d'Arts i Oficis*, 1916. Pencil, India ink and watercolor on paper, 22 × 28 cm. Historic Archive of the Col·legi d'Arquitectes de Catalunya, Girona. Photograph by Jordi Puig.

understand what this "very modern" German model signified in the context of Catalan *noucentisme* and why it was eventually aborted. On January 1, 1916, the Girona city council changed hands from the regionalist to the republican party. Suddenly, those who had promoted the School of Arts and Crafts found themselves in the opposition. Problems immediately arose. In October, the council majority passed a proposal in order "to give up the establishment of a School of Arts and Crafts in Girona" (Anon. 1916: 4). In November the school's board resigned and, not surprisingly, by December 14 the mayor announced that the building would be turned into the Teachers' School. Soon after, in February 1917, Athenea declared bankruptcy and was unable to pay its rent, but de facto political reasons had also strangled it.

Conclusion

Within a period of six months, both of Rafael Masó's major *noucentista* projects in Girona had died. In a small provincial town, *noucentisme* was unable to transcend party politics and, as Tarrús and Comadira rightly point out, it was always seen "to respond to a party's orientation—the Lliga [Regionalista]—and as Masó's own cultural enterprise … In fact, the death of Athenea is a consequence of *noucentisme*'s inability to take root in Girona, where Masó's work is seen more as the author's personal whim rather than the aesthetic alternative of a generation" (2007: 78). The Lliga's ideologues had defined and presented *noucentisme* as a national style when, in fact, a large segment of the population saw it as the refined, elitist and distant art of a conservative bourgeoisie. Republicanism gained acceptance among the growing urban working class and in 1917 *noucentisme*, together with the Lliga Regionalista, entered a period of crisis—first ideological, then political.[15] In Girona, Masó embodied the Lliga's ideals and that status stopped him from reaching across political and social barriers.

All studies on Masó, as well as the majority of cultural studies of this period, tend to omit another historical fact that was a major force in the crisis of *noucentisme*: since early August 1914, Europe had been at war. Spain remained officially neutral during the First World War, but public opinion, intellectual figures and political parties held heated debates as the conflict evolved. Conservative factions, as noted by Díaz-Plaja, gradually shifted from openly Germanophile positions toward a general defense of neutrality, in conformity with the aims of a propaganda campaign ignited in Spain by Germany itself (1973: 75–87).[16] Eugeni d'Ors, following the example of the French writer Romain Rolland, also made an effort to stay "above the battle," which was interpreted as a way of hiding his actual sympathy for Germany.[17] Masó probably even felt closer to German culture than *noucentista* leaders such as Ors and Prat de la Riba and did not hide his admiration. His impressions from his trip to Germany were still fresh and he was eager to implement the cultural and educational models he had witnessed. Unfortunately, he tried to do so at the worst possible time. There is no evidence that Masó openly declared his support for the Central Powers, but in Girona he must certainly have been seen as a Germanophile. In a manuscript from 1917, looking back at his school project, he wrote in these terms:

> This is how it began in Germany, for instance and this is how this powerful Empire has attained such high perfection and strength. This is how those very powerful German institutions called *Kuntsgewerbes Wereins* (sic), today located in the main industrial centers of this Empire, began: in Munich and Dresden, in Cologne and Frankfurt. This is how they began: the friends of the Fine Crafts and the craftsmen united, setting up a drawing classroom, another one as a workshop and another for exhibitions. The artists worked together with the official craftsmen and together they worked toward ennoblement until they arrived at a complete transformation of the trade. (Masó 1917: 4–5)[18]

Masó's opinions were certainly at odds with the dominant view in Catalonia. The year 1916, in particular, was a tragic time on the western front and Barcelona officials, by then openly Francophiles, prepared a "*saison française*" to help the propaganda effort. It was then that a group of Catalan artists and writers, joined by diplomats and political leaders, offered to bring the famous Salon from Paris to Barcelona. On April 23, 1917, the Salon des Artistes Français, the Salon de la Société Nationale des Beaux-Arts and the Salon d'Automne, opened at Barcelona's Palace of Fine Arts.

The year 1917 was also a turning point for *noucentisme*. Prat de la Riba died in August, when Spain was in the middle of a political, military and social crisis. Masó, indefatigable, did not give up. In 1920 he was involved again in the establishment of the Galeria dels Bells Oficis (Gallery of the Fine Crafts) in Girona. Owned by the Busquets brothers, who were cabinetmakers and interior decorators, it was a small art gallery in the spirit of Athenea, although it was more commercially oriented and never offered any formal education.[19] Masó's educational vocation also persisted in his role as a mentor figure for the so-called

"second *noucentista* generation" of artists and craftsmen in Girona. He worked with the potter Frederic Marcó, who specialized in black clay pottery and architectural ornaments; the cabinetmaker Adolf Fargnoli; and the blacksmiths Nonito and Ramon Cadenas, among others.[20] But in an article he wrote about Ramon Cadenas, Masó still regretted that "If, instead of a fleeting and circumstantial mentorship like the one he has had, he could have obtained a real one in an appropriate School of Fine Crafts, we are certain that this character which sooner or later will manifest itself in his works would have developed years ago and now we would fully enjoy even more high-quality and definitive foundry works" (Masó 1919: 1).

Noucentisme and, in particular, its architecture, have been overshadowed by *modernisme* and deserves greater attention and closer study. Regardless of their fortunes, there are no precedents in the art history of modern Spain for this attempt to achieve artistic and cultural reform. For the first time Catalan political leaders, artists, manufacturers and intellectuals made a joint effort to establish an education and production system centered on vernacular crafts. This was, in turn, part of a larger modernizing agenda mirrored in the British and German models at a time when Catalonia was itself coming of age as a modern (stateless) European nation. As in Rafael Masó's case, it is a history of many truncated projects, a story that would later repeat itself during the Spanish Second Republic in the first half of the 1930s. Even if it was only a brief period, for the first time in modern Spain craft became a defining element of art and architecture. For Masó and his generation, tradition and modernity were not conflicting values, as it was precisely the work of highly qualified craftsmen that would make possible the coexistence of technology and art.

Acknowledgements

I am grateful to Pere Vivas and Jordi Puig for their help and generosity in helping me obtain all the illustrations in this article. Unless otherwise indicated, all translations are mine.

Notes

1 See Bassegoda Nonell, Juan. 1976. El único artículo periodístico escrito por Antonio Gaudí. *Miscellanea Barcinonensia: revista de investigación y alta cultura* no. XLIV, pp. 13–26.

2 See Navas, Teresa. 1986. La Casa Escofet de Mosaic Hidràulic, 1886–1936. *Tesi de llicenciatura* [BA Thesis], Universitat de Barcelona; Subias, Ma. Pia. 1989. *Pujol i Bausis: centre productor de ceràmica arquitectònica a Esplugues de Llobregat*. Esplugues de Llobregat: Ajuntament; Fondevila, Mariàngels and others. 1998. *Gaspar Homar, moblista i dissenyador del modernisme*. Barcelona: Museu Nacional d'Art de Catalunya/Fundació "la Caixa"; Casanova, Rossend. 2002. Gaudí and his Collaborators: Artists and Industrials Around 1900. In *Gaudí 2002: Miscellany*, ed. Daniel Giralt-Miracle, pp. 254–77. Barcelona: Ajuntament de Barcelona/Planeta; Carbonell, Sílvia and Josep Casamartina. 2002. *Les fàbriques i els somnis: modernisme tèxtil a Catalunya*. Terrassa: Centre de Documentació i Museu Tèxtil; Casamartina, Josep. 2002. *L'interior del 1900: Adolf Mas, fotògraf*.

Terrassa: Centre de Documentació i Museu Tèxtil; and Sala, Teresa-M. 2006. *La Casa Busquets: una història del moble i la decoració del modernisme al déco a Barcelona*. Barcelona: Universitat Autònoma.

3 See Ealham, Chris. 2005. *Class, Culture and Conflict in Barcelona, 1898–1937*. London: Routledge, pp. 1–6; and Romero Salvadó, Francisco J. 1999. *Spain,*

Arts and Crafts style in 1925. Over the next few years, with the assistance of cabinetmaker John Schmidt, he quickly began to design and make his own sculptural furnishings and interiors using sharply prismatic elements together with asymmetrical organic forms. Esherick was always reluctant to discuss the development of his art but, in later years, was credited with creating a modern and distinctly American style. However, some of Esherick's inspiration came from the formal and theoretical aspects of anthroposophical design as conceptualized by Rudolf Steiner. Esherick's first encounter with Steiner's philosophy came in 1920 when he was introduced to Louise Bybee, a pianist who provided accompaniment for a form of artistic movement known to anthroposophists as eurythmy. By 1928, Esherick also had first-hand knowledge of anthroposophical design as it was being practiced by Fritz Westhoff for the Threefold Commonwealth Group, an anthroposophical outpost in New York City. Although it is clear that Esherick was familiar with Steiner's design philosophy, there was a strong anti-German sentiment ignited by the First and Second World Wars. Because of this Esherick never mentioned anthroposophy in any of his published interviews; yet his interest can be discerned in his designs, as well as his later description of his creative process.

Keywords: Wharton Harris Esherick, Rudolf Steiner, Fritz Westhoff, Louise Bybee, anthroposophy, Threefold Commonwealth Group, American studio furniture

Wharton Harris Esherick (1887–1970) was first introduced to a wide audience as a designer of sculptural furniture and interiors in 1940, when his "Pennsylvania Hill House" was unveiled as part of the "America at Home" exhibition, a later addition to the 1939 New York World's Fair.[1] Architect and author George Howe explained, "The peculiar quality of the sculptor's products come from the fact that he actually lives and works in the Pennsylvania hillside among the trees—oak, hickory, walnut and cherry—which he cuts down, seasons in his lumberyard and tools with his own hands."[2] Nearly two decades later, in 1958–59, the Museum of Contemporary Crafts in New York City held Esherick's first retrospective exhibition, showcasing ninety pieces and presenting him as a modern, home-grown American artist with strong roots in the tradition of colonial craft.[3] In promoting the exhibition, assistant director Robert Lauer wrote:

> One fascinating aspect of Esherick's work is that it is indigenous at the same time that is personal. It is as American as Independence Hall. One comes to the conclusion that Esherick absorbed during his years of residence in and near Philadelphia, qualities and characteristics that are peculiarly our own. In a period that has seen the tremendous wave of Scandinavian influence on furniture and interior design in the United States, it is reassuring that Esherick has been able to express our native tradition in the contemporary idiom.[4]

Art critic and long-time friend Gertrude Bensen reaffirmed these ideas, writing in *Craft Horizons* in 1959 that Esherick was

"… a Thoreau of our time, dean of American craftsmen, contemporary Chippendale."[5] Lauer and Bensen both helped to mythologize Esherick's career while he was still alive and it is this celebratory, facile account that has persisted.[6]

Esherick did very little to contradict this written record or to expand upon his personal history in ways that might undermine this myth. His hand-built studio, located in the woods outside Paoli, Pennsylvania, fits perfectly with his image as a rural artist untainted by foreign influences. Likewise, in the 1920s, when Esherick first began to make sculpture and furniture, the search for an authentic modern American art was a current topic of discussion among writers such as Paul Rosenfeld, Waldo Frank and Sherwood Anderson—all part of the "second Steiglitz circle."[7] So it is easy to see why Esherick's public image was fashioned in this manner.

Tacitly Esherick accepted his role as a home-grown American designer, but this outcome could not have been anticipated in the early years of his career. He had many connections to New York City and Philadelphia, as well as a full awareness of European trends and ideas. Although writings by Henry David Thoreau and Walt Whitman were part of his personal library, so, too, were books on impressionism, post-impressionism, German expressionism, cubism, primitivism, Bauhaus design and even Scandinavian architecture and furniture.[8] In the 1910s, his impressionist paintings were featured in many galleries, but few sold. With early encouragement from print connoisseur and then curator Carl Zigrosser (1891–1975), he turned to the somewhat more lucrative business of printmaking and book illustration in the early 1920s.[9] Esherick's first published prints were for *Rhymes of Early Jungle Folk* (1922), a primer on human evolution for children by Mary Marcy (1877–1922), who had also been managing editor of the *International Socialist Review*. Esherick's illustrations for Walt Whitman's *Song of the Broad-Axe* (1924) and *As I Watched the Ploughman Ploughing* (1928) came later. Altogether he illustrated eight books between 1922 and 1930.

Esherick started making furniture in the Arts and Crafts style, as well as small sculptures and toys, in the mid-1920s. Then, in 1925, he began his informal woodworking apprenticeship with John Schmidt (b. 1891) a European-trained *menuisier*.[10] Working closely with Schmidt, he began to focus his creative energies on the design of large, sculptural furniture and, by 1928, several of his early modern pieces were featured in the short-lived, but important, American Designers' Gallery in New York City.[11] Esherick also had a long relationship with the Hedgerow Theater in Moylan-Rose Valley, Pennsylvania and, in 1930, made the set design for Henrik Ibsen's *When We Dead Awake*. The writers Sherwood Anderson (1876–1941) and Theodore Dreiser (1871–1945), both of whom had plays produced by the Hedgerow Theater, were among his close friends. Clearly Esherick had close ties to avant-garde circles in these early years.

Still, Esherick's rapid development as a furniture designer was remarkable. From trestle tables in 1925 to heavy, relief-carved pieces in 1927 to asymmetrical, prismatic forms in 1928, his style shifted dramatically over a period of only several years. In the ensuing decade, he fully reinvented himself as a modern designer, sculptor

and craftsman and garnered the support of three major private patrons: German businesswoman Helene Koerting Fischer, New York photographer Marjorie Content (a friend of the painter Georgia O'Keeffe) and Philadelphia lawyer and judge William Curtis Bok (who had gone to Russia in 1932 to learn about the Bolshevik Revolution). By this time, he had also begun to explore free organic curves. The shift in Esherick's medium and his full embrace of modernism was especially apparent in the Bok house, which was showcased in *Country Life and The Sportsman* in 1938 (Figure 1).

Fig 1 Staircase in the entrance foyer in the Curtis Bok house, with the library chimneypiece and the entrance to the music room visible at the far left. Photographed by Edward Quigley in 1937. Courtesy of the Wharton Esherick Museum.

In exploring Esherick's influences during the late 1920s, there is one particular thread that has been noted in the literature, but not sufficiently examined and that is his personal relationship with the New York City followers of Rudolf Steiner (1861–1925), the Austro-Hungarian philosopher and founder of anthroposophy.[12] Although Steiner's name was never mentioned in any of Esherick's publicity, some of the earliest books in Esherick's collection were by Steiner—*The Gospel of St. Luke* (1909), *The Way of Initiation* (1910), *The Spiritual Guidance of Man and of Mankind* (1915), as well as *Ways to a New Style in Architecture* (1927). Today, the Wharton Esherick Museum acknowledges Steiner's architectural free curves as an influence on Esherick's organic style, but there were also important personal connections that have not been previously explored.[13] Esherick's rapid evolution as a modern artist paralleled his understanding of Steiner's design theories (often known today as "organic functionalism" or "spiritual functionalism") and his awareness of the anthroposophical furniture of Fritz Westhoff (1902–80).

Rudolf Steiner, Anthroposophy and the Threefold Commonwealth Group

Rudolf Steiner's Anthroposophical Society was a splinter group of the Theosophical Society that Helena Petrovna Blavatsky (1831–91) had founded in New York City in 1875. Steiner had been attracted to the Theosophists and their aim of synthesizing science, religion and philosophy and he became the general secretary of the German section of the society in 1902. During the early years of the twentieth century, Steiner's

public lectures on "spiritual science" drew the attention of many modern artists, perhaps most famously Wassily Kandinsky (1866–1944), who acknowledged the role of Theosophy in his 1911 book *Concerning the Spiritual in Art*.[14]

In 1913, when Theosophist leader Annie Besant (1847–1933) followed the counsel of Charles Webster Leadbeater (1854–1934) and identified the young Jiddu Krishnamurti (1895–1986) as the second incarnation of Christ, Steiner broke his ties to the group and established the Anthroposophical Society in Germany. Steiner accepted most of the basic tenets of the Theosophists, but developed his own terminology and approach. He saw life as a trinity of the human body, soul and spirit and believed that he could guide the spirit in its journey to connect with the larger spiritual realm of the universe. Articulate, intense and charismatic, he gave numerous lectures in Munich and Berlin, authored dozens of books and embraced the arts (which he had introduced into the Theosophical Society work at the Congress of the Federation of European Sections of the Theosophical Society in Munich in 1907).[15] New approaches to painting, sculpture, colored glass, furniture, architecture, theater and a form of artistic movement that he called eurythmy were inspired by his ideas.

Membership of the Anthroposophical Society grew rapidly and Steiner saw the need for an organizational center. He executed his architectural design for a double-domed building in scale models using wax and plasticine (an oil-based modeling clay generally used for sculpture). The dome had a long history of cosmological symbolism, with the Roman Pantheon being a prime example, but Steiner's intersecting domes represented the unification of the earthly human soul (or psyche) with its spiritual nature.[16] Steiner also argued that the human being was dynamic and metamorphic, evolving over time as the expression of unseen, natural and spiritual forces. The energy associated with each stage of this process could be expressed through art. Art, in turn, was capable of communicating this powerful transformation by generating feelings and emotion, thus giving visible form to something that, in Steiner's view, was spiritual and akin to music.[17]

Construction of Steiner's largely wooden building began in 1913 in Dornach, Switzerland, not far from the German border, though it was slowed down by the First World War. Steiner called it "the Goetheanum" after the German writer Johann Wolfgang von Goethe (1749–1832), whose scientific and literary work he had studied, written about and edited.[18] He did not prescribe a specific, unified formula, but he gave numerous formal and methodological examples that outlined a stylistic approach. Steiner explicitly rejected art based on the superficial imitation of natural forms, a method that had been advanced by many nineteenth-century design theorists. He pointed to the famous German architect Gottfried Semper (1803–79) as a negative example of this kind of "materialistic" emphasis.[19] Steiner also dismissed thoughtless historicism, although he argued that classical and Gothic architecture had originally had a legitimate spiritual source that guided form and so were valid expressions in their time. He emphasized that the artist had to be sensitive to the energy in all nature and should express that

Fig 2 "Staircase in Vestibule" inside the first Goetheanum in Dornach, Switzerland. From Rudolf Steiner, *Ways to a New Style in Architecture* (London and New York: Anthroposophical Publishing Co. and Anthroposophic Press, 1927).

force through form and color in a manner consistent with the laws of nature. In practice, this meant that certain aspects of his designs bore a vague resemblance to organic objects such as a skull, a nutshell, or a seed pod. For example, the sculptural, curving form and the femur-like vertical support of Steiner's reinforced concrete vestibule staircase in the first Goetheanum is evocative of a hip joint, a part of the human body that would be fully engaged when using the stairs (Figure 2).

At some point before the First World War, Rudolf Steiner and Ralph Courtney (1885–1965) met in Paris and became friends.[20] Courtney was American, but educated in England and had begun reading Steiner's work in London. Although he held a law degree, he focused his energies on journalism, first in London and then in Paris as a foreign correspondent for the *New York Tribune*. In the spring of 1921, Courtney came to New York to work for the *New York Herald*, but his larger goal was to be an ambassador for Steiner and anthroposophy.[21] He joined with the St. Mark Group, which had begun in 1910 as the first attempt to introduce Steiner's ideas in the United States.[22] The group generally met on the seventh floor of Carnegie Hall and this is where Courtney was introduced to pianist Louise Bybee.

In 1922, Courtney and Bybee rented an apartment building on the corner of Sixth Avenue and West Fifty-Sixth Street. This provided another meeting place for the anthroposophists, as well as apartments for subletting to friends and students. At the end of that same year, the first Goetheanum was destroyed by arson. In response, Steiner conceptualized a new design, one that was both highly organic and sharply angular and began the process of rebuilding, this time using reinforced concrete (Figure 3).

In November of 1923, the Threefold Commonwealth Group was established in New York City, with Courtney, Bybee and Charlotte E. Parker among the founding members.[23] The name came from *The Three-Fold Commonwealth* (1923), the authorized

Fig 3 Rudolf Steiner, Second Goetheanum in Dornach, Switzerland. From "Anthroposophische Architecktur," *Das Werk* (Mai 1931): 133.

English translation of one of Steiner's books. In the text, Steiner assessed the dire conditions in Germany after the First World War and he offered in accessible language principles for a healthy human community, again based on three guiding social concepts—free individual spiritual expression, equal political rights and economic interdependence and cooperation. The New Yorkers were ready to give these ideas a try.

By 1924 the Threefold Commonwealth Group had rented a second property at 135 West Fifty-Sixth Street. In all likelihood, this was where Parker, Bybee and Gladys Barnett first began cooking for the Threefold community and where Barnett painted large red and gold flames around a defunct fireplace in the dining room, a decorative feature reportedly inspired by a lecture on anthroposophical architecture.[24] One of Steiner's artistic concepts, independently adopted by the American architect Louis Sullivan (1856–1924), was that form should follow function.[25] Steiner explored this idea in various ways, focusing on the metamorphosis of design and though he never meant it to be taken literally or symbolically, his Boiler House for the Goetheanum did have flame-like projections along its chimney (Figure 4). The painted fireplace decoration described above is atypical of anthroposophical design (and suggests that some of Steiner's ideas were difficult to grasp, even for his followers), but it was conceived in that context.

In 1925 the Threefold Commonwealth Group moved all of its activities to 207 West Fifty-Sixth Street and at some point thereafter they decided to open a public restaurant with mostly vegetarian fare in the basement of that building. No photographs are known, but the written descriptions of this space evoke a decor that was both creative and thrifty. The walls had map-like designs, with cracks in the plaster providing the borders between areas of brightly painted color. Crystal-shaped lampshades were made from stiff paper and the bowls came from Chinatown.[26]

By 1927 Fritz Westhoff had joined the Threefold Commonwealth Group; earlier that same year he began working for the Edison Company in New York City. His background was a unique blend of

Fig 4 Rudolf Steiner, Boiler House for the Goetheanum in Dornach, Switzerland. From "Anthroposophische Architecktur," *Das Werk* (Mai 1931): 139.

engineering, art and anthroposophy.[27] Born in Paraguay to German parents, he had lived in both Paraguay and Uruguay and at age eleven went to Greiz, Germany, to attend secondary school. His father, Ferdinand, was a founding member of the Anthroposophical Society and it is worth noting that Fritz also had several prominent artists in his family, including sculptress Clara Westhoff (1878–1954), his aunt, poet Rainer Maria Rilke (1875–1926), her husband and painter Helmut Westhoff (1891–1977), her brother. Fritz first came to New York City in 1923, returned to Germany in 1925 and then came back to New York in late 1926, newly trained as a mechanical engineer.

Once Fritz Westhoff had discovered the Threefold Commonwealth Group, he began to design and make furniture for its members; his earliest work may date to 1927. He was already familiar with anthroposophical concepts through his family and he would have known Steiner's *Ways to a New Style in Architecture*, as well as the photographs of Steiner's work that Threefold members brought back from Dornach.[28] In 1928 Westhoff's furniture was photographed and featured in *The New York Times* and in *The Mayflower's Log*, a privately printed magazine of the Mayflower Hotel in Washington, DC.[29] Neither article indicated where the photographs were taken. Likewise, the authors did not mention the Threefold Commonwealth Group or anthroposophy, suggesting that Westhoff did not want to publicize these facts. Instead, his furnishings were highlighted as examples of modernism: sculptural forms composed of short diagonal lines and soft edges. The original photograph that was reproduced in *The New York Times*, however, survives in the Threefold Archives (Figure 5). Moreover, his desk chair emulates the massive, sculptural and faceted chairs which were placed at the bases of the twelve columns of the small cupola in the first Goetheanum and illustrated in *Ways to a New Style in Architecture* (Figure 6).

In fact, there are many other prints of Westhoff's furniture that appear to come from the same photography session. These pieces also feature faceted edges and prismatic forms that are clearly anthroposophical designs. The designs include many tables and mirrors of triangular form, which had obvious significance for the Threefold Commonwealth Group and captured the balanced and interdependent triadic frameworks explained in anthroposophy. There was also a skewed bureau with soft, tactile pulls made for Charlotte Parker that reflected knowledge of Steiner's lecture on the acanthus leaf (Figure 7). Steiner had asserted that

Fig 5 Fritz Westhoff, desk, chair and lamp, photographed in 1928 by the Knickerbocker Photo Service, New York. Photograph also appeared in *The New York Times* (July 15, 1928). Threefold Archives, Threefold Educational Center, Chestnut Ridge, New York.

Fig 6 "Small Cupola with Stage" inside the first Goetheanum in Dornach, Switzerland. From Rudolf Steiner, *Ways to a New Style in Architecture* (London and New York: Anthroposophical Publishing Co. and AnthropoSophic Press, 1927).

when early man became sensitive to the cosmic power of the Earth and the Sun, this awareness was expressed through the depiction of ornamental plants in forms that extended upward from a wide base; pointed buds represented the Earth forces, while open palms were emblems of Sun forces.[30] In this context, the bureau, which appears to have been situated near a window (and photographed with a plant), did seem to be alive and sensitive to the forces of nature. The wide base and the asymmetrical tilt suggest the pull of gravity, while the bud-like swelling and point at the top seem ready to sprout. The life-like quality of this piece was further suggested by the smooth, bean-like pulls that were designed to accommodate the upward palm and grasp of the hand.

room was conceived as a whole. This shelf is surrounded by flat, overlapping pieces of wood, each cut in free curves; this design expresses energy directed downward, into the earthly realm. It also resembles flowing water—which, of course, would nurture upward growth (as suggested by the bureau and the built-in bookshelf). Westhoff almost certainly did not intend a literal interpretation here, but rather a unified design that expressed the earthly human soul rising upward toward its descending spiritual nature—the same concept Steiner had used in designing the double dome of the Goetheanum. This same idea seems to have been expressed in yet another variation in Westhoff's anthroposophical design for Ralph Courtney's bureau (Figure 8). This

Fig 7 Fritz Westhoff, chest of drawers for Charlotte Parker (75 × 35 × 16 in.), c.1927–28. Threefold Educational Center, Chestnut Ridge, New York.

The architectural interior of Parker's room, probably somewhat later than the dresser, was also designed by Westhoff. A portion of it was captured in another photograph. On the far left and right are doors that are faceted at the top, a common anthroposophical motif that suggests the power of cosmic forces. In the middle is a built-in bookshelf that has the same silhouette as the bureau, suggesting that the

Fig 8 Fritz Westhoff, wardrobe for Ralph Courtney, c.1927–28. Courtesy of David Adams.

Fig 9 Fritz Westhoff, chairs (33¼ × 18 × 21¾ in.), pine, c.1927–28. Threefold Educational Center, Chestnut Ridge, New York. Photograph by Mark Sfirri.

piece of furniture is strongly asymmetrical, yet it brings together ascending and swelling curves on the left and descending trapezoidal facets on the right.

Another photograph from this series shows the card table and side chairs in the style featured in *The Mayflower's Log* and offered for sale at Stern Brothers' department store in New York City. The contour of these furnishings is composed of short lines that intersect at sharp angles. The chairs sit on three legs—another metaphorical link to anthroposophical concepts (Figure 9). The backs are pierced in a symmetrical pattern, with two teardrop shapes flanking a central bifurcated lozenge. At first glance, the design resembles a sectioned nut or seed pod—that is, a natural form. It is also possible to perceive the design of the backs as two raised hands on either side of a head—a gesture indicating a willingness to embrace. The chairs visually communicate an invitation to sit.

By 1929 the Threefold Commonwealth Group had purchased a building at 318 West Fifty-Sixth Street and the Threefold Vegetarian Restaurant reopened on the street level. The floors above the restaurant were turned into small residential apartments and the basement was the Threefold Workshop, where Westhoff worked. The renovations were done by Carl Schmidt (1895–1975)—no relation to John Schmidt—with direction from Courtney and the furniture was designed by Fritz Westhoff.[31]

In conceptualizing the Threefold Vegetarian Restaurant, Westhoff's challenge was to develop and arrange furnishings that expressed the transformation of food in the form of minerals, plants and animals (each of which was recognized by Steiner as possessing distinct natural energies) into human energy. In his overall design, Westhoff consciously blended clean, modern lines with odd, severe geometry juxtaposed against soft curves. He ended up with a scheme in which the sharpest lines and most prismatic forms were visually anchored to the floor. These angular qualities metamorphosized upward into more curvaceous lines in the furniture and along the walls; the most organic and energetic lines were found in the wall sconces (Figure 10). Westhoff's sturdy chairs, similarly, were linear at the base and displayed an asymmetrical scallop motif at the crest (Figure 11). Here, he applied Steiner's thinking about the transformation of a circle to communicate directional motion, as well as to encourage dynamic progression through a building. The overall design, with its vertical evolution from static to dynamic, is an appropriate anthroposophical

Fig 10 Threefold Restaurant, 318 West Fifty-Sixth Street, New York City, designed and constructed c.1929–30. Threefold Archives, Threefold Educational Center, Chestnut Ridge, New York.

expression of the holistic interdependence of minerals, plants and animals, as well as the energizing effect of food on the human body.

Taken together, these examples demonstrate that anthroposophical design had some formal qualities that were comparable to other modernist design. The underlying intent, however, was not to just to create something new and different, but to be sensitive to nature and to respond to the physical and spiritual needs of the human being as articulated by Steiner. As these few examples reveal, soft, organic curves coexisted with sharp, prismatic lines. Wharton Esherick was paying attention.

Wharton Esherick's Anthroposophical Inspirations

Wharton Esherick's link to the New York anthroposophists began in 1920 with his introduction to Louise Bybee at the Gardner-Doing Camp in Paul Smiths, a community on the Lower St. Regis Lake in the Adirondack Mountains of New York.[32] The camp had been founded in 1916 by vocalist Gail Gardner and dancer Ruth Doing.[33] It was probably Esherick's wife, Letty, who initiated this contact after the family had spent the winter of 1919–20 at Marietta Johnson's School of Organic Education in Fairhope, Alabama. She had become interested in learning and teaching "rhythmic dancing" and, from that point on, Esherick and his family spent part of their summers at the Gardner-Doing Camp and also at the Ruth Doing Music Camp on nearby Lake Chateagay.

Bybee had discovered Steiner's 1904 book *Theosophy: An Introduction to the Supersensible Knowledge of the World and the Destination of Man* toward the end of

Fig 11 Dining chairs (36¼ × 16⅜ × 18 in.) from the Threefold Restaurant, 318 West Fifty-Sixth Street, New York City, designed and constructed c.1929–30. Threefold Archives, Threefold Educational Center, Chestnut Ridge, New York. Photograph by Mark Sfirri.

the First World War while recovering from scarlet fever in Paris. Later, in New York City, she became an active participant in the St. Mark Group. At the dance camps in the Adirondacks, Bybee offered readings of Steiner's lectures.[34] It also appears that she stimulated interest in the anthroposophical art of eurythmy, gestures intended to communicate a visible form of speech and music.[35] Although Esherick was not an anthroposophist or formal member of the Threefold Commonwealth Group, his friendship with Louise Bybee at the early date of 1920 makes it clear that he was fully aware of their activities. Esherick was also present at the very beginning of the Threefold Commonwealth Group in New York City; in December 1923, they exhibited his block prints, together with a few of his watercolors and oil paintings.[36]

As mentioned earlier, Esherick began exploring furniture through the construction of trestle tables, including one made for a log house at Ruth Doing's Music Camp around 1925.[37] With its use of oak and its heavy proportions, low-relief carving, through-tenons and knock-down construction, the table has a medieval sensibility that fitted comfortably within the parameters of the Arts and Crafts movement. It also displays a pattern of inscribed circles and lozenges along the perimeter of the top, some of which were abstract designs that had been created by Esherick together with Doing's students as they listened and responded to music. The exercise recalls Steiner's discussion of visible forms presented through music or tone eurythmy.

In 1926, Esherick laid the foundation for a new house and studio in Paoli, Pennsylvania and thus began a structure that would continue to evolve over the years and which is now the Wharton Esherick Museum. That same year, Esherick began to work on a red oak print cabinet and desk (Figure 12). Completed in 1927, it is a heavy design; the slightly tapered base has two side-hinged doors, each of which contains four narrow vertical panels, relief-carved in non-repeating linear designs. One panel has a basket weave, while the others are abstracted designs based on branching plants and trees. The carved panels resemble printing blocks, a form consistent with the function of a print cabinet. This was the kind of clever, yet

Fig 12 Wharton Esherick, print cabinet and desk (78¼ × 56½ × 16½ in.), red oak, 1927. Wharton Esherick Museum. Photograph by Mark Sfirri.

and theoretical aspects of anthroposophical design. In 1928, he completed a five-sided walnut and ebony breakfast table with four chairs (one with three legs) and a bench.[38] He was clearly inspired by Westhoff's short, diagonal lines and planed corners, as well as his pierced, three-legged side chairs. Yet Esherick also had his own ideas. None of his chairs matched and all displayed asymmetrical open triangles and tetragons, together with faceted edges (Figure 13). Given that Esherick had so little experience with wood at this time, it is not surprising that his construction techniques were flawed and the chairs, in particular, were improperly engineered. Still, these pieces are lively, imbued with a sense of energy.

clearly legible, symbolism that Steiner did not endorse, but it seems similar to Barnett's idea of painting flames on the wall around a hearth and it may have been a conscious attempt to bring life to a piece of furniture.

By 1928, if not earlier, Esherick almost certainly had seen Westhoff's furniture designs for the members of the Threefold Commonwealth Group and it is tempting to speculate that at some point they were introduced by Bybee. In any event, Esherick must have seen the photographs of Westhoff's work that were taken in 1927–28. As Esherick continued to think about furniture, he explored both formal

Fig 13 Wharton Esherick, chairs (various sizes 32½–36 × 13½–14 × 15½–18 in.), walnut and ebony, 1928. Courtesy of Peter Esherick. Photograph by Mark Sfirri.

Fig 14 Wharton Esherick, desk (28 × 15½ × 16½ in.), walnut and padauk, 1929 (originally with a rectangular aluminum top, ¼ in. thick, that barely covered the base; top replaced with walnut in 1962). Wharton Esherick Museum. Photograph by Mark Sfirri.

Another of Esherick's projects for 1929 was a "walnut table desk—aluminum top."[39] Aluminum was a mark of high-style modern design, probably selected because the piece was going to the American Designers' Gallery in New York City. It did not sell and the top was replaced with walnut in 1962 (Figure 14).[40] Nonetheless, the desk retains its original base—two skewed, yet symmetrical, drawer pedestals that taper upward. This piece is usually regarded as an example of Esherick's prismatic style (sometimes linked to the German expressionist film, *The Cabinet of Dr. Caligari*, which had opened in Berlin in 1920 and was released in New York in 1921).[41] Esherick was also quite familiar with German expressionist prints, cubist sculpture and art deco designs and these, too, have been cited as influences.[42] However, it is far more likely that this piece was another exercise in anthroposophical design. The pedestals, which are strikingly similar to the skewed bureau by Westhoff discussed earlier, slant inward toward the person sitting at the desk and appear compressed by the weight of the top. Likewise, the tiered drawers, together with their inset triangular pulls, seem to be squeezed downward by the force of gravity. A desk is a place where humans think and work and where invisible ideas are rendered into tangible written products. It is tempting to suggest that Esherick was illustrating this concept when he designed these inverted pedestals.

Esherick's most experimental pieces of early furniture were commissioned by Helene Koerting Fischer (1879–1970), president of the Schutte and Koerting company in Philadelphia.[43] Fischer met Esherick as early as 1929, the year in which she acquired *Finale*, his sculpture in black walnut that was exhibited at the Hedgerow Theater in Rose Valley, Pennsylvania.[44] That purchase quickly led to a commission for a base; Esherick then modified the design so that it also served as a Victrola cabinet. With the help of John Schmidt, it was completed in 1930. Thereafter, Fischer commissioned a corner desk (1931), a sewing cabinet (1933),

Fig 15 Wharton Esherick, corner desk (49 × 52 × 35 in.), walnut and ebony, 1931. Collection of Barbara Fischer Eldred. Photograph by Mark Sfirri.

a "flame" lamp (1933) and a bench/ record cabinet (1938) for her home in West Mount Airy, Pennsylvania, as well as a number of pieces for her company in the 1940s.[45]

Fischer's corner desk is the best known of Esherick's early pieces and it is a tour de force of design, engineering and craftsmanship (Figure 15). Here, Esherick brought together the many anthroposophical elements that he had explored only a few years earlier—the overall crystalline form (without a single right angle), the irregular and faceted triangles, as well as the compressed and skewed pedestal of drawers. The asymmetry is similar to that of Westhoff's bureau for Ralph Courtney (see Figure 8). Displaying walnut and ebony on the exterior, Esherick's desk opens only after a hidden key and a concealed lock are discovered. Then it unfolds in a complex manner, like a Chinese puzzle, slowly revealing a functional inner workspace that was crafted from padouk (also known as padauk or vermillion), which would originally have been a striking orange-red color.[46]

Louise Campbell, one of Esherick's friends, was so taken by this piece that she prepared an ode in its honor. In this short excerpt, she situated the desk in an artistic context that was thoroughly modern (and by no means indigenously American):

> Words by Gertrude Stein, E. E. Cummings and James Joyce; to music by Stravinsky and rhythmics by Mary Wigman; with explanatory notes by D. H. Lawrence and Henry Ford. Merged into sculptural expression by Wharton Esherick.[47]

Campbell also described it as a "piece of sculpture that evolved itself into a desk, or rather, a desk that evolved itself into a sculptural creation." Steiner, of course, had emphasized that art could communicate the process of change in the natural world, illuminating the metamorphosis associated with germination and growth and Esherick knew Westhoff's expressions of these ideas. The bright orange-red color found within the seemingly impenetrable prismatic form evoked a sense of vitality and life.[48] This aesthetic decision also fitted with Steiner's lessons on the spiritual aspects of color, which he called the "element where the soul lives."[49] This complex and remarkable desk appeared static and solid when closed, but fully active and energetic when open.

From July to October of 1931, Esherick was in Europe, traveling through Germany, Sweden, Norway and Denmark in the

company of the German artist Hannah Weil (who in 1932 would become Helene Fischer's daughter-in-law). They visited museums and galleries, with a special interest in seeing the sculpture of Carl Milles (Carl Emil Wilhem Andersson, 1875–1955) and the work of Ernest Barlach (1870–1938).[50] It does not appear that they went to the Goetheanum, but after his return to Pennsylvania, Esherick continued to experiment with anthroposophist forms.

In 1933, Esherick created the flame lamp for Helene Fisher, as well as a prismatic sewing cabinet (Figure 16). Both of these objects were placed at the head of a daybed in the same sitting room as the corner desk. When and where Louise Campbell saw these pieces is not clear, but she did record her impressions:

> The bedside table is an imagination triumph. I like very much the tall candle-like affair—its form sets off one's imagination—Peer Gyntish—except that to me it's disturbingly phallic. But is that something to complain about? Or is it?
>
> Fortunately I was alone and could touch and not be chastised. The lovely black wooden latch that holds the doors of the desk; the dull but satin-smooth table-tops; the narrow ribbons in black in the table; your characteristic carvings—if the purpose of art is to evoke emotion, then you have succeeded and more than well, in the outward forms you fashion.
>
> I close with the heartfelt wish that your collection has evoked even more than an emotional response in some of the purse-proud dowagers who push themselves around these sacred precincts.[51]

Because this was on a scrap of paper seemingly cut out of a larger letter, some text may be missing. Nonetheless, it is clear that Campbell's musings relate to Helene Fischer's commissions. The flame lamp provides a natural visual metaphor for light, although such a literal design concept is an oddity for Esherick. At the same time, in its abstraction, it appears to be another attempt to understand Steiner's ideas about form and function and it does bear a certain resemblance to Steiner's 1915 Boiler House—photographs of which were likely shared through the Threefold Commonwealth Group.

Fig 16 Helene Fischer's sitting room, photographed 1937. Wharton Esherick's 1933 flame lamp and walnut sewing cabinet can be seen in the center. Collection of Barbara Fischer Eldred.

Campbell's passage is also interesting because it explicitly alludes to the idea that "The purpose of art is to evoke emotion." Although this was by no means a new concept, it is remarkable that her observation was not applied to the "fine arts" of painting, sculpture, or architecture—but rather to furniture, typically regarded as a "decorative art." Esherick, however, had fully erased this distinction. This important breakthrough, together with his selective application of anthroposophical design ideas, was the key to his success and his later influence.

In 1935, Esherick was hired by the Boks to work on their stone farmhouse in the vicinity of Gulph Mills, Pennsylvania. Over the next three years, he worked on the outside light posts, the entrance hall, the library and adjacent music room, the living room, the dining room and the den. He also created sculpture for Bok—*The Judge* in 1936 and *The Philosopher (Jew)* with its own pedestal in 1937. With the exception of several wrought iron gates provided by Samuel Yellin (1885–1940), everything was designed by Esherick. Upon completion in 1938, the Bok house was showcased by Sophia Yarnall in *Country Life and The Sportsman*.[52] Photographs by Edward W. Quigley (1898–1977) accompanied her detailed description. Each room had a different concept and, at the same time, there were some design elements that connected adjacent rooms, creating overall cohesion.

Yarnall said nothing about Steiner, but his influence is apparent. The sweeping spiral staircase in the entrance foyer was noted earlier and compared with the curving west entrance staircase of the first Goetheanum (Figures 1 and 2). Photographer Edward Quigley captured another view that he titled *Staircase Abstraction*, which further reveals Esherick's application of rhythmic lines and curves, as well as metamorphosis in design (Figure 17).[53] Likewise, the sculptural entrance to the Boks' dining room was as abstract and organic as the architecture of the second Goetheanum (Figure 18). At the same time, Esherick was not working for an anthroposophist client and thus had no obligation to produce "authentic" anthroposophical designs. So some ideas were strictly his own. For example, the bold, prismatic fireplace in the library was much more regular, geometric and repetitious than most of Steiner's or Westhoff's designs, but it swelled upward with energy,

Fig 17 Edward Quigley, *Staircase Abstraction*, 1937. From Robert A. Laurer, *The Furniture and Sculpture of Wharton Esherick, December 12, 1958– February 15, 1959* (New York: The Museum of Contemporary Crafts of the American Craftmen's Council, 1958).

accommodate the touching, grasping, pulling and pushing of the human hand.[55]

Noticeably absent in Yarnall's article was any discussion of Thoreau or Walden, or Esherick's distinctly American style. Nor did she link Esherick's work to any of the "isms" that had engaged the art world. Rather, her emphasis was on Esherick's "sculptured wood"—a phrase that had earlier been used to describe Westhoff's furniture designs. She observed that the balanced use of active and inactive lines—words that echoed some of Wharton's earlier prints based on dance, but also were elements of anthroposical design. Yarnall concluded with the observation that the Bok house was "lustily alive," a description that evokes Steiner's

Fig 18 Wharton Esherick, archway made for the passage between the dining room and foyer in the Curtis Bok house, 1935–38. Photograph by Rick Echelmeyer. Courtesy of Robert Edwards.

Fig 19 Wharton Esherick, library of the Curtis and Nellie Lee Bok house (Gulph Mills), Radnor, Pennsylvania, 1936. Carved oak, stone, copper hearth. Room 8½ × 16 × 20 ft. Fireplace and doorway 8½ × 16 × 5 ft. Philadelphia Museum of Art: Acquired through the generosity of W. B. Dixon Stroud, with additional funds for preservation and installation provided by Dr. and Mrs. Allen Goldman, Marion Boulton Stroud and the Women's Committee of the Philadelphia Museum of Art, 1989.

projecting visually and emanating warmth (Figure 19). The faceted doors leading from the library to the music room better maintained anthroposophical lines, while suggesting a dramatic stage curtain. Yarnall also commented on Esherick's latches, writing, "The satinwood latches have been carved concavely on the book room side and convexly in the other room—as if to be persuasive about the entering guest and reluctant to let him go."[54] Esherick's hand-carved door handles captured the gesture of pressing with the thumb, as well (Figure 20). This, too, is consistent with Steiner, who explained that latches and handles needed to

Fig 20 Wharton Esherick, door handles in the Curtis Bok house, photographed by Edward Quigley in 1937. From Sophia Yarnall, "Sculptured Wood Creates the Unique Interiors of the Curtis Bok House," *Country Life and The Sportsman* 74, no. 2 (1938): 72.

invocation of life-force energy in imagining a "new style in architecture."

Only in later years did Esherick openly acknowledge a spiritual element in his art, although he did not elaborate on the point. As part of the publicity for the 1958–59 retrospective, Lauer wrote:

> Esherick's manner of handling wood is his greatest distinction; the wood is allowed to express itself naturally. Forms seem to grow out of the particular piece of wood used. The life in wood is not interrupted, in a sense, but enhanced through Esherick's sensitive working of it. Details

of environment that ordinarily escape the attention of designers, like latches and switchbox plates, are infused with warmth and meaning.[56]

Ten years later, in conjunction with his 1968 exhibition at the Peale House Galleries in Philadelphia, Esherick used similar words to describe his artistic process, "I begin to shape as I go along. The piece just grows beneath my hands. I treat furniture as though it were a piece of sculpture … I dig up what I do out of my own soul."[57]

As far as can be determined, Esherick was never a bona fide anthroposophist and he did not refer to Steiner in any of his published interviews. For that matter, he did not say much about any of the theoretical aspects of his work, even as he absorbed and understood modern art within a remarkable circle of friends and acquaintances. It is, therefore, probably wise not to over-amplify any single interpretation of his work. Nonetheless, it is certain that Esherick found in Rudolf Steiner and the New York anthroposophists one particularly rich source of ideas, both formally and theoretically and he continued to think about these ideas throughout his career, even if he did not fully adhere to Steiner's style.

Esherick continued to attract patrons until the end of his life, but most of his professional honors came after the 1958–59 exhibition at the Museum of Contemporary Crafts. This was, of course, at the end of an era that had just witnessed the intense anti-communist atmosphere promoted by Senator Joseph McCarthy, an era that included the Hollywood blacklist. Esherick's reluctance to elaborate in the press on his early artistic inspiration is understandable—

his circle of friends in the 1910s and 1920s had included anarchists, socialists, communists and German anthroposophists. It is no surprise that Esherick passively accepted his image as the Thoreau of wood, or the dean of American craftsmen.

Acknowledgments

The authors express their sincere gratitude to Dr. David Adams, Professor in Art History at Sierra College, California, for his thought-provoking and critical review of an earlier draft of this paper, as well as his generosity in sharing unpublished research on Fritz Westhoff. They also appreciate the guidance provided by Glenn Adamson and the two anonymous peer reviewers.

Notes

1 For more on Esherick, see *Woodenworks: Furniture Objects by Five Contemporary Craftsmen* (St. Paul: Minnesota Museum of Art/Renwick Gallery, 1972); Michael A. Stone, "Wharton Esherick: Work of the Hand, the Heart and the Head," *Fine Woodworking* no. 19 (November/ December 1979): 50–57; K. Porter Aichele, "Wharton Esherick: An American Artist-Craftsman," in *The Wharton Esherick Museum: Studio and Collection* (Paoli, PA: Wharton Esherick Museum, 1977, 1984); Wharton Esherick Museum, *Half a Century in Wood, 1920–1970: The Woodenworks of Wharton Esherick* (Paoli, PA: Wharton Esherick Museum, 1988); Edward S. Cooke, Jr., Gerald W. R. Ward and Kelly H. L'Ecuyer, *The Maker's Hand: American Studio Furniture, 1940–1990* (Boston: MFA Publications, a division of the Museum of Fine Arts, 2003). A biography on Esherick by Mansfield Bascom is forthcoming.

2 George Howe, "New York World's Fair 1940," *Architectural Forum* (July 1940): 36.

3 Robert A. Laurer, *The Furniture and Sculpture of Wharton Esherick, December 12, 1958–February 15, 1959* (New York: The Museum of Contemporary Crafts, 1958). The Museum of Contemporary Crafts was founded in 1956 by Aileen Osborn Webb. It was renamed the American Craft Museum in 1986 and in 2002 became the Museum of Arts and Design.

4 Robert Lauer, "Museum Events: Esherick Exhibition," in the Wharton Esherick Artist File, Museum of Modern Art, New York.

5 Gertrude Benson, "Wharton Esherick," *Craft Horizons* (January/February 1959): 33.

6 See e.g., Susan R. Hinkel, "Wharton Esherick: Dean of American Craftsmen," *American Woodworker* no. 12 (February 1990): 36–42; Hoag Levins, "A Thoreau in Wood: The Making of Wharton Esherick," *Modernism Magazine: 20th Century Art and Design* 1, no. 2 (Fall 1998): 22–29; Edward S. Cooke, Jr., "The Long Shadow of William Morris: Paradigmatic Problems of Twentieth-Century American Furniture," in Luke Beckerdite, ed., *American Furniture 2003* (Milwaukee: Chipstone Foundation/University Press of New England, 2003).

7 See Wanda M. Corn, *The Great American Thing: Modern Art and National Identity, 1915–1935* (Berkeley: University of California Press, 1999).

8 Esherick's personal library remains intact at the Wharton Esherick Museum and was cataloged in 1995.

9 See Reba White Williams, "The Weyhe Gallery between the Wars, 1919–1940," (Ph.D. diss., City University of New York, 1996); Allan Antliff, "Carl Zigrosser and the Modern School: Nietzsche, Art and Anarchism," *Archives of American Art Journal* 34, no. 4 (1994): 16–23.

10 Personal communication between Mark Sfirri and descendents of John Schmidt. Schmidt had emigrated from Fehértemplom, Hungary (today Bela Crkva, Serbia), to the United States in 1907.

11 Karen Davies, *At Home in Manhattan: Modern Decorative Arts, 1925 to the Depression* (New Haven, Connecticut: Yale University Art Gallery, 1983), pp. 91, 100; Marilyn F. Friedman, "Defining Modernism at the American Designers' Gallery,

New York," *Studies in the Decorative Arts* 14, no. 2 (Spring/Summer 2007): 79–116. None of Esherick's objects seem to appear in the archival photographs from the American Designers' Gallery and very little was written about Esherick's work by the contemporary critics. Our thanks to Marilyn Friedman for sharing this information.

12 David Adams, "Early Anthroposophical Design in North America: The Architecture and Furniture of Fritz Westhoff (1902–1980)," paper presented at the annual meeting of the College Art Association, New York City, February 14, 1990; Reinhold Johann Fäth, "Rudolf Steiner Design: Spiritueller Funktionalismus Kunst" (Ph.D. diss., University of Konstanz, 2004), pp. 258–59, notes 78–79.

13 Mansfield Bascom, "Wharton Esherick Museum Docent's Manual" (1991), p. 19.

14 See for example Sixten Ringbom, *The Sounding Cosmos: A Study of the Spiritualism of Kandinsky and the Genesis of Abstract Painting* (Åbo, Finland: Åbo Akademi, 1970).

15 Rudolf Steiner's writings are available at the Rudolf Steiner Library of the Anthroposophical Society in America, Ghent, New York. Additional information at http://www.anthroposopy.org/library.html, accessed on December 1, 2008.

16 David D. McKinney, "The Place of the Skull: Rudolf Steiner and the First Goetheanum," *Athanor IX*: 55–64; Hagen Biesantz and Arne Klingborg, *The Goetheanum: Rudolf Steiner's Architectural Impulse* (London: Rudolf Steiner Press, c.1979), pp. 16–20, 34.

17 David Adams, "Rudolf Steiner's First Goetheanum as an Illustration of Organic Functionalism," *Journal of the Society of Architectural Historians*, 51/2 (January 1992): 191.

18 Steiner worked at the Goethe archives in Weimar from 1888–96. He also wrote *The Theory of Knowledge Implicit in Goethe's World-Conception* (1886), *Goethe as the Founder of a New Science of Aesthetics* (1889) and *Goethe's Conception of the World* (1897).

19 Rudolf Steiner, *Ways to a New Style in Architecture* (London and New York: Anthroposophical Publishing Co. and AnthropoSophic Press, 1927), pp. 2–8.

20 Ralph Courtney, "Recollections of my Early Years in the Anthroposophical Society," n.d. Our thanks to David Adams for sharing a copy of this manuscript.

21 "A Short History of the Threefold Group," n.d.; "Founding of Threefold Group: Talk Given by Constance Ling at the Threefold Farm," November, 1976. Threefold Archives, Threefold Educational Center, Chestnut Ridge, New York. We thank Rafael Manacas for providing access to the Threefold Archives. See also "A Brief History of the Threefold Community," Threefold Educational Center, Chestnut Ridge, New York, 2008. http://www.threefold.org/about_us/history_and_chronology/history/page1.aspx, accessed on August 1, 2008.

22 For more on the St. Mark Group, see Hilda Deighton, *The Earliest Days of Anthroposophy in America* (n.p., n.d.), Threefold Archives, Threefold Educational Center, Chestnut Ridge, New York. This book contains a lecture given by Deighton in New York City on February 14, 1958.

23 The other initial founding members were Gladys Barnett (later Hahn), Margaret Peckham, Alice Jansen and Reinhardt Müller.

24 In our initial draft of this article, we relied on a detailed timeline of the early years of the Threefold Commonwealth Group attached to "Talk Given by Constance Ling to a Group of Newly Arrived Institute Students," September 16, 1974. Threefold Archives, Threefold Educational Center, Chestnut Ridge, New York. We subsequently discovered that many of Ling's dates were incorrect. Our current understanding of this early history is based on the work of David Adams, who conducted interviews with Threefold members during their later years, together with records compiled from the *Manhattan Telephone Directory* and the *Manhattan Address Telephone Directory* from 1924 to 1939.

25 See David Adams, "Form Follows Function: The Hidden Relationship Between Architecture and Nature," *Towards* (Winter 1989): 10–19, 40, reprinted by the Center for Architectural and Design Research, Penn Valley, California.

26 [Ruth Pusch], "The Threefold Community … What Brought It About?" typed manuscript, n.d.; "Talk Given by Constance Ling to a Group of Newly Arrived Institute Students, September 16, 1974, Side Room of Auditorium, Spring Valley." Threefold Archives, Threefold Educational Center, Chestnut Ridge, New York.

27 Adams, "Early Anthroposophical Design in North America."

28 Although *Ways to a New Style in Architecture* was an important source, Steiner also lectured extensively on this topic. See also Christian Thal-Jantzen, ed., *Architecture as a Synthesis of the Arts: Lectures by Rudolf Steiner* (London: Rudolf Steiner Press, 1999), pp. 51–148.

29 Walter Rendell Storey, "New Summer Furniture is Picturesque," *The New York Times*, July 15, 1928: SM10; Monica Selwin-Tait, "The Setting of a New Age," *The Mayflower's Log* 4, no. 4 (June 1928): 36–38.

30 Steiner, *Ways to a New Style in Architecture*, p. 6.

31 Schmidt was a cabinetmaker hired through a German agency on West Eighty-Sixth Street. Joseph Wetzel, "In Memory of Carl Schmidt, July 30, 1895–February 10, 1975," *Threefold Gazette* (Spring 1975). This reference was kindly shared by David Adams. Carl Schmidt did not arrive in New York until 1929, after Fritz Westhoff had already begun designing and building furniture for the Threefold Commonwealth Group.

32 Account book, 1920–32, "Catalog, 1920–21," pp. 10–20, Wharton Esherick papers, Archives of American Art, Smithsonian Institution, Washington, DC, microfilm 4559. The paintings listed for this year are grouped by different areas—Chester Valley, Fairhope, Adirondacks and Cape Cod. While in the Adirondacks, Esherick produced watercolors titled *Dancers under the Trees*, *Dancers by the Lake*, *Dancers in the Breeze* and *Chateaugay Lake* and oil paintings titled *Dancers in the Moonlight*, *Twilight Dancers* and *The Dancer*. In 1920, he gave the following watercolors as gifts: *Twilight Clouds* to Gail Gardner, *Moonlight Dancers* to Ruth Doing and *Summer Cape Cod* to Lou Bybee.

33 See "Musical News and Notes," *The New York Times* (July 10, 1910); Jane Dudley, "The Early Life of an American Modern Dancer," *Dance Research: The Journal of the Society for Dance Research* 10, no. 1 (Spring, 1992): 5–8; "A Paradise for Boys and Girls: Children's Camps in the Adirondacks," The Adirondack Museum, 2003, http://208.109.195.98/search.asp?q=gardner-doing, accessed on July 31, 2008. Gail Gardner (also a friend of Carl Zigrosser) was an American contralto who, by 1910, had given many concerts in Europe and had gained recognition for her performance of German lieder. During these tours, Bybee was her pianist. Ruth Doing was an Irish dancer with a specialty in "rhythms."

34 "Talk Given by Constance Ling," pp. 2–3.

35 Anon., (probably Martha Bosch), "Unraveling a Mystery at the Main House," *The Listener* (May 1984). Threefold Archives, Threefold Educational Center, Chestnut Ridge, New York. Eurythmy was conceptually different from the system of eurhythmics developed by the French-Swiss musician and educator, Emile Jacques-Dalcroze (1865–1950).

36 Account book, 1920–32, "Three-Fold Commonwealth, sent Nov. 26, 1923, Exhibition Dec. 1–Dec. 15."

37 "Unraveling a Mystery at the Main House." In this two-page, typed and illustrated summary, the table for Ruth Doing was said to date to 1923 and made at Lake Chateaugay. See also "A Paradise for Boys and Girls: Children's Camps in the Adirondacks," The Adirondack Museum, 2003. http://208.109.195.98/search.asp?q=gardner-doing, accessed on July 31, 2008. This source indicates that the Ruth Doing Music Camp opened at the Lake Chateaugay site in

1925 and so the table likely dates to that year or later. The table was moved to the Threefold Community, where it remains today.

38 Account book, 1920–32, "1928 Other Work," p. 99. Esherick also designed garden chairs, painted stump chairs, a painted armchair, a bed for the studio and a padouk table with walnut legs for the author Theodore Dreiser, whom he had met in 1924.

39 This "table-desk" seems to have been started in 1928.

40 Mansfield Bascom, "Wharton Esherick Museum Docent's Manual" (1991), p. 37.

41 "The Screen," *The New York Times*, April 4, 1921, p. 22; see also Sherwood Anderson, *Sherwood Anderson's Memoirs* (New York: Harcourt, Brace and Company, 1942), p. 357; Bascom, "Docent's Manual," p. 28; Roberta Smith, "Design Review: When Craft is Wedded to Machine Production," *The New York Times*, January 5, 1996, C25. Anderson had seen the film when it came out and given that Anderson and Esherick met during the winter of 1919–20 in Alabama, Esherick was probably aware of it. The Wharton Esherick Museum often cites this film as the influence for Esherick's outhouse (built in the late 1930s and reproduced by the museum in 2008).

42 See e.g. Aichele, pp. 7–8; Robert Edwards and Robert Aibel, *Wharton Esherick (1887–1970) – American Woodworker*, May 3–July 20, 1996 (Philadelphia: Moderne Gallery, 1996), pp. 1, 4; Janet Kardon, ed., *Craft in the Machine Age: The History of Twentieth-Century American Craft* (New York: H. N. Abrams/American Craft Museum, 1995), p. 84.

43 "The Story of the Schutte and Koerting Company" (Trevose, PA: Schutte & Koerting, n.d.); personal communication between Mark Sfirri and York Fischer. Helene Fischer was born in Germany to a Catholic family and was a daughter of Dr. Ernst Körting (d. 1921), a successful physicist, mechanical engineer and entrepreneur. Her father had established his first business with his brother in 1871 in Hanover, Germany and then in the 1870s had opened branches in London, Philadelphia, Vienna and Paris.

44 Interview with Ruth Esherick Bascom and Mansfield Bascom for the Archives of American Art, conducted by Marina Pacini at their home in Paoli, Pennsylvania on March 26, 1991, pp. 56–57.

45 The pieces commissioned for the Schutte & Koerting Company are now in the Philadelphia Museum of Art.

46 For a detailed description, see Mark Sfirri, "Anatomy of a Masterpiece: The 1931 Corner Desk by Wharton Esherick," *Woodwork* no. 112 (August 2008): 52–56.

47 Louise Campbell, "Portrait of a Desk" (1931), Barbara Eldred Collection. Two slightly different versions of this page-length poem are in this collection. Campbell was one of Theodore Dreiser's many lovers and later his secretary and editor.

48 See also Wassily Kandinsky, *Concerning the Spiritual in Art* (Boston: MFA Publications, 2006), p. 79. Kandinsky writes, "Light warm red … gives a feeling of strength, vigor, determination, triumph."

49 See Steiner, *Ways to a New Style in Architecture*, pp. 49–59.

50 Interview with Hannah Weil Fischer, conducted by Mansfield Bascom, transcribed July 23–August 9, 2007. This material was kindly shared by York Fischer Jr.

51 Account book, 1929–38, p. 75.

52 Sophia Yarnall, "Sculptured Wood Creates the Unique Interiors of the Curtis Bok House," *Country Life and The Sportsman* 74, no. 2 (1938): 67–74.

53 For more on this photographer, see *Edward Quigley: American Modernist, April 17 to June 1, 1991* (New York: Houk Friedman, 1991).

54 Yarnall, p. 67.

55 Adams, "Rudolf Steiner's First Goetheanum," p. 182.

56 Lauer, "Museum Events: Esherick Exhibition."

57 "Wharton Esherick Retrospective Opens at Peale House Galleries—Oct. 31," News Release, Pennsylvania Academy of the Fine Arts, Oct. 28, 1968, Museum of Modern Art, Wharton Esherick Artist File.

Primary Text

Commentary

Paul Caffrey

Paul Caffrey is a design historian at the National College of Art and Design, Dublin.

The official Irish government report *Design in Ireland* (hereafter "the Scandinavian Report") was published in February 1962. The publication of this report, the most significant document in the history of Irish design, gives an in-depth account of the state of Irish craft, design, and education, at a moment of extraordinary importance in the development of modern craft and industrial design.

The report was highly critical and controversial. Its recommendations were studiously ignored by government and civil servants, who ensured that the report was shelved. But the report could not be buried. It had a lasting influence on the way we perceive Irish craft and design, and despite the official silences, had an impact on the ensuing development of Irish design and the restructuring and reform of design education in Ireland. The report therefore has a double value. Not only does it give an account of the state of Irish design practice and education; it also provides fascinating insights into the thinking of the Scandinavian designers and their self-perceptions at a time when Scandinavian modernism was the accepted standard for modern design.

The report was commissioned in direct response to the need to promote Irish industry and stimulate exports. The government agency responsible for the improvement of industrial design was the state agency Córas Tráchtála Teo (known as CTT or in English as the Export Board). This had been established in 1952. In 1961, Córas Tráchtála set up a design section. The leading figure in Córas Tráchtála was the organization's general manager, William H. Walsh.[1] He was the most influential person in Irish design who believed in creating a new Irish design identity. Walsh was the single driving force behind the Scandinavian report. He wanted the report to support his view that small businesses in Irish industry could succeed only if exports were encouraged by the government.

For exports to compete on the open market, they had to be well designed.

Irish design needed significant state support. Walsh had control of the finances in Córas Tráchtála and he wanted to take practical steps to improve the status and appreciation of craft and the standard of Irish design. He planned to establish a state-funded design consultancy funded by Córas Tráchtála. This was an unorthodox proposal and the Department of Finance did not approve. In 1963, however, Walsh realized his vision and founded Kilkenny Design Workshops.[2] It is often stated that the workshops were inspired by the Scandinavian report, but this is not so. Walsh had planned to found the workshops prior to the publication of the report. However, the report added weight to his plans for a state design consultancy.

Walsh was particularly interested in Danish design and, through Ake Huldt, had formed contacts in Sweden and Finland in the 1950s. He was therefore well placed to bring together a group of Scandinavian designers. The findings of the group were recorded by Paul Hogan, a young Irish graduate of the Royal Academy of Copenhagen who was head of the design section of Córas Tráchtála.[3] Hogan also made many of the practical arrangements for the visit. He was to devote his entire career to Irish design promotion and in 1992 was the driving force behind the foundation of the European Institute for Design and Disability.

The report contained the findings of five distinguished designers. Ake Huldt, a Swedish architect and designer, was at that time manager of the Swedish design centre, Svensk-Form. Of the visitors he was the one most familiar with the situation in Ireland and had already been invited, as director of the Swedish Council of Industrial Design, to make the selection of products to be included in the Irish Design Exhibition 1956.

Kaj Franck, the renowned Finnish designer, was invited to join the group. In 1961 he was head of the design departments at both the ceramic firm Arabia and the glass factory Notsjö. He was also art director at the Finnish School of Industrial Design.

The three other members of the group were Danish and held academic appointments at the Royal Academy of Copenhagen: Erik Herlow, an architect and professor of industrial design; Gunnar Biilmann Petersen, professor of industrial graphics and typography; and Erik Christian Sorenson, an architect who had worked previously at the Massachusetts Institute of Technology. Timmo Sarpaneva, the distinguished Finnish glass designer and colleague of Tapio Wirkkala, was to have been a sixth member of the group, but was prevented from joining by a government commission.

The members of the group were sent a large amount of reading material about the history and present economic situation of Ireland, as well as statistics relating to industry. Visual material illustrating contemporary Irish design was also sent. The visit took place over two weeks in April 1961, which coincided with Easter that year (Easter Sunday, April 2, marked the beginning of the visit). The visitors studied every aspect of Irish design, focusing particularly on textiles. They were impressed by the quality of the raw materials: linen, wool, poplin, and tweed. They were shown examples of hand knitwear, printed linen, carpet manufacture, glass, ceramics, silverware, souvenirs,

packaging, and stamp design. The group visited factories such as Waterford Glass and design colleges around Ireland, notably the National College of Art in Dublin, the School of Architecture in University College, Dublin, the colleges of technology in Dublin and the art colleges in Waterford and Cork. Meetings were arranged with the Royal Institute of Architects in Ireland. A series of five seminars for industrial designers was held at the end of the visit.

The report rejected the notion that standards in industrial design for exports could be easily improved. They argued that designs must be rooted in the culture that produces them, and that well-designed goods should be aimed at the home market. If such goods were successful at home, they wrote, they would also be suitable for export. They warned against slavishly copying Scandinavian designs, and argued that products should be distinctively Irish in style. The report is also highly critical of the lack of design education in schools.

The report is divided into four sections. Section I, excerpted here, is a survey of Irish design. It attempts to show the place of tradition in Irish design. It identifies three main areas: rural handicraft, the Georgian tradition, and early Christian culture. The use of ornament in Irish design is explored. The report's authors were against the use of complex patterns and motifs, which they describe as unsuited to modern production methods and domestic interiors.

Ironically, given the core principles forwarded in the report, the detailed recommendations departed from historical Irish material culture in important ways. First, the report dismissed the Georgian tradition—the strongest and most influential strand in Irish design—as alien and imported. This was a gross misrepresentation but was one that was commonplace in Ireland at the time. The work of Irish craftsmen, silversmiths, and glassmakers interpreting rococo and neoclassical designs was therefore ignored. The Scandinavians were worried that there would be a neo-Georgian revival of pastiche classical forms.

The Scandinavians also made their own aesthetic preferences clear in recommending that designers should be encouraged to rely on the inherent qualities of the materials, with an emphasis on proportion, function, production, and ergonomics. Ornament should be avoided; wood should be left unpolished and unstained; ceramics, silver, and glass left unornamented. Materials should be unbleached, untreated, and left natural. In other words, the group rejected the Irish love of strong color and ornament. Instead they advocated the adoption of Scandinavian modernism with its respect for the craft tradition, sensitivity to materials, and simplicity of form.

The section in the report on the glass industry was the most controversial. Waterford Glass was a model of luxury, handcrafted and export-driven design. It had an international reputation. Yet the shapes of the glass were criticized by the Scandinavian group, and the firm's designs were dismissed as overly ornamented pastiches of historic designs, relying on the buyer's sentimentality.

The remainder of the report, not reproduced here, concerned logistical considerations about Irish design development. Section II is devoted to design promotion, exhibitions, and the media. The report's authors identified the need for a design research archive. Section III is a study

of design education, and Section IV includes a proposal for a new Irish Institute of Visual Arts. Although unrealized, this idea would have an influence on Irish design education reform thinking in the 1970s. The greatest criticism was reserved for the outdated methods of teaching at the National College of Art (now NCAD).

The report was unusual in that it was produced by a government agency, but was highly critical of state agencies, the education system, and private enterprise. The report was forceful in its recommendations, not watered down by a consultative process or team of civil servants; Paul Hogan literally recorded what the Scandinavian visitors said. Although the report shook the complacent and provincial Irish art and design world, politicians and public servants wanted it ignored. Questions were asked in *Dail Eireann* (the lower house of parliament) and the minister for education was attacked for inactivity. There was a broader nationalistic rejection of the findings, which was led by Desmond Fennell. He did not regard Scandinavian culture, which he saw as essentially godless and materialistic, as a suitable model for Irish culture. Fennell presented his argument in terms of the ancient conflict between the Celts and Viking invaders. Traditionally, Ireland had either imitated British or American culture in a provincial way or had looked to Catholic Europe for inspiration. He suggested that Ireland turn to France, Spain, and Italy as a more suitable model. There had been an exhibition of Italian industrial design in Dublin in 1955, which could have been a starting point for this alternative approach.

The first results of the Scandinavian Report were in the area of design promotion. Gunnar Biilman Petersen was commissioned to curate an exhibition of Japanese design. The exhibition opened at the Danish Arts and Crafts Exhibition Centre in Copenhagen in 1962 and traveled to Dublin in 1963. Exhibitions of chair design and textiles followed. There was an exhibition of design from the nine EEC countries in 1963, the year Ireland first applied to join. Córas Tráchtála formulated a strategy for design in Ireland based on the findings of the report. It identified three main problems: the low level of design consciousness in Ireland, especially among manufacturers; the absence of design management; and the need to develop a modern education system for designers. Córas Tráchtála organized a series of seminars and exhibitions, kept a register of designers, imported foreign expertise to advise manufacturers, and gave grants to manufacturers to employ professional designers. These were successful short-term solutions to compensate for the shortage of designers. Over the course of the 1960s, 200 new designers were employed in Ireland. However, the most important legacy of the Scandinavian Report was that it provided William Walsh and Córas Tráchtála with the rationale and external support for the establishment of the Kilkenny Design Workshops, which he modeled on the Plus Craft Workshops at Frederikstad in Norway, which had been established by the Norwegian entrepreneur Per Tannum.

Notes

[1] I am indebted to the late William H. Walsh for clarifications and for the information on the relationship between the Scandinavian Report and the establishment of the Kilkenny Design

Workshops. Interview with W. H. Walsh at the Royal Dublin Society, November 5, 1998.

2 See generally: Nick Marchant and Jeremy Addis, *Kilkenny Design: Twenty-One Years of Design in Ireland*, (Kilkenny and London: KDW and Lund Humphries, 1984).

3 Interview with Paul Hogan, Sandymount, December 20, 1995. See Paul Caffrey, "Paul Hogan, Irish Design Management Consultant" in *Contemporary Designers*, ed. Sara Pendergast, Detroit: St. James Press, 1997, pp. 373–74.

probably be true to say that without some reasonably developed form of art education in the various levels of schools in Ireland, it will be impossible to produce the informed and appreciative public so necessary as a background to the creative artist.

We would emphasize at this stage that it was not our mission in Ireland to recommend the 'adoption' of Scandinavian design, indeed we would strongly advise against the unqualified transplantation of features from Scandinavian countries to Ireland, even if such action would have passing economic benefits. We feel that the result of such an approach would be to kill what can be saved and what still exists of the original Irish values and culture, and stifle the development of true Irish tradition and the great opportunities which the present situation seems to offer.

Scandinavian production in the realm of arts and crafts and industrial design is largely based on the development of traditional crafts and abilities. We believe that one of the great factors in the success of Scandinavian design abroad is that the production is based on what has already been established and on local demand rather than on export requirements. The Scandinavians designed and manufactured work for Scandinavians and the ultimate export success depended on this outlook.

In general, the best-designed products we found in Ireland were those based on traditional craft industries, successfully interpreting the Irish tradition. Outstanding examples were the Donegal tweeds and the hand-knitted sweaters of traditional design. At the other end of the scale, we found many products which were badly designed and executed, and which, in our view, would not have the slightest chance of competing successfully on the world market. We understand that many of the industries we visited have been established only relatively recently and, taking this into consideration, their accomplishments have been remarkable.

Nevertheless the successful development of these industries will depend on their placing much greater emphasis on design than heretofore. We gained a strong impression in many of the factories we studied that product design was not considered with the serious attention it demands, and that the designer, when he existed, was regarded as a somewhat frivolous addition to the staff, rather than having the status of a key member of the management team.

The question of education of designers will be explored in succeeding pages, and at this stage we shall only say that we encountered in Ireland the extraordinary situation of a multiplicity of art, architectural and craft schools, not one of which appeared to us capable of adequately satisfying the needs of the country in regard to design.

We have in the following pages reviewed various institutions and industries and have tried to do so frankly and in a constructive manner, keeping very much in mind the fact that Irish products contribute fundamentally to the picture of Ireland presented to the outside world, and that Irish export trade and the tourist industry depend heavily on design.

Some of the proposals may seem far-reaching, but we would stress that isolated attacks on the problem will have very little impact. A designer here or a seminar there will not appreciably alter the situation. A

Fig 1 Rushwork products from Slievebawn Handcrafts, Strokestown, County Roscommon. The writers of the report admired the workshop's baskets, as well as the traditional St. Brigid's cross made on the saint's day (February 1) each year.

coordinated scheme for raising the standards in schools, buildings, factories, in education and in industry should be aimed at.

This, in our opinion, can best be accomplished by the creation of an Irish institute devoted to the promotion of the visual arts. This recommendation is dealt with fully in a later section of the report.

In carrying out the recommended programme all the elements of Irish society will have a part to play – the government, educationalists, manufacturers, architects and designers, department stores and the organs of publicity, the press, radio and television. In particular the departments of the government have a most significant contribution to make towards raising the level of design by reviewing the design of public building, office furnishings, publications, stamps, etc. and taking positive steps to remove those features which are bad and ugly and reflect no credit on Ireland. It is obvious that the Churches also can be of particular help by raising their standards of architecture and decoration.

In our view, Ireland, by virtue of her lack of sophistication in matters of design, has a unique opportunity, denied by circumstances to many more developed countries, of making a great contribution, not alone to her own prosperity and culture, but to the culture of Western Europe. We believe that with courage and foresight, the possibilities can be realized.

Design in Ireland

When in the introduction to this report we warn against the Irish acquisition of Scandinavian features, it is due to our knowledge that modern Scandinavian production is the result of a cultivation of special local conditions. Up to the time when exports began to increase, the bulk of Scandinavian-designed products were created for an appreciative home market and what led to a wider interest abroad was a sense of quality in regard to materials and craftsmanship, and, to a considerable extent, the application of traditional forms to modern conditions.

The use of borrowed forms of decoration is common enough in modern production, but shallow utilization of old or foreign models has never led to the creation of anything of value. In our passage through Irish production, therefore, we have constantly paid attention to what valuable national characteristics we could find, which would enable Ireland to put on the market something out of the ordinary with a distinct Irish quality.

We have searched after good Irish design tradition and we have been asked what we meant by 'Irish tradition'. According to the Concise Oxford Dictionary, 'tradition' is opinion or custom handed down from ancestors to posterity: artistic principles based on accumulated experience or continuous usage. What has been handed down in Ireland and what has been accumulated from experience has today in Ireland two or three different manifestations.

The most perceptible are the rural handicraft, the Georgian tradition, and the early Christian culture.

In tweed-weaving, knitting, etc., the rural handicraft is still alive and so is even the Georgian tradition but in so attenuated a form as to be difficult of application. As to the early Christian culture, its artistic manifestations had lapsed long before the Georgian period and thus today's use of the early ornaments is scarcely more of a tradition in Ireland than elsewhere. However, Ireland has abundant sources of inspiration in the high crosses and ornamental objects and they have been utilized for the past seventy-five years. It deserves notice that the designers have almost invariably turned to the queerest and most complex motifs, the interlaced animals, etc., which are apt to lose their proper character when reproduced in modern processes and will rarely harmonize with the surroundings of our time. On the other hand there is an unemployed treasure of Irish patterns fit for design usage: the simple granite carvings and the small ornaments scattered over the pages of the illuminated manuscripts. We would not, however, like to see designers turning to these sources merely to bring something new on to the market. This ancient culture is worthy of artists who will understand and respect the simple strength and organic rhythm of the antiquities.

The Georgian tradition we regard as English, not Irish, in its origins, even if the considerable supply of Georgian-ism in Ireland is modified to give it some especial characteristics. In England, its natural home, it is barely alive and at the last extremity.

Fig 2 A so-called "hand-carved" wool carpet sample, made by the Dixon Carpet Company, Oughterard, County Galway, founded in 1957 under the name V'Soske-Joyce, Ltd.

This reminds us of a parallel with Denmark. Both Ireland and Denmark have a large, overpowering neighbour, and as Ireland has been influenced by England, so Denmark has been influenced by Germany. For many years the Danish kings and nobility were German or almost entirely so, and furthermore, since the Reformation, Denmark had adopted German Lutheranism. Ireland never adopted the English form of worship, but it has had an English government and English-minded ruling class. It has had materials and products from England, and for unnumbered years the handicraft and architectural culture of the country has been influenced by England. But it has seemed to us that the Irish when confronting the English market have frequently adopted the most common and hackneyed features of English production.

Of course every country must be influenced by its neighbours and it can be said straight away that the particular forms of Danish furniture, silver, ceramics, etc., which led to economic success in later years, were based to a large extent on what came from Germany. But the core of Danish style derives from the work of a series of Danish artists, architects, painters and sculptors who through generations were aware of the essential qualities of materials. They animated each other in their common sympathy for exquisite material and its properties, for treatments which paid regard to proportions, problems of production and use, and finally, to the normal human scale. This to an extent which makes ornamentation almost superfluous and which at any rate is not unduly influenced by passing fashions.

To illustrate this spirit, it should be mentioned that for many years Scandinavian artists have avoided staining and high-gloss polishing of wood. Similarly in many cases they have refrained from ornamenting silver or ceramics and concentrated instead on cultivating the relationship between form, clay and glazing, a development which is now accepted as an art in its own right.

A very close relation to this respect for the structure of materials is to be found in the Scandinavian comprehension of colour. In some countries one often finds rooms with nearly the same colour on walls, ceilings, windows, doors and upholstery, as if the entire room had been soaked in a dyer's vat. We find a modern cult which attempts to make exactly the same shades of colour on wool, silk, paper, plastics, paints, etc. In Scandinavia, for instance, such efforts would not be popular as Scandinavian designers believe that different materials with differing functions claim different colours. To the Scandinavians, moreover, there is a perceptive relation between colour and material which is dictated by the very nature of the latter. Kaare Klint, the furniture designer who had the greatest influence on Danish production, always preferred unstained leather for upholstery. He tolerated neither de-greasing nor levelling of colour but wanted to have the natural dark line along the backbone in the middle of the chairs, etc. The same artist felt the impracticality of clear or violent colours for carpets, just as he found it against the order of nature to make roses to walk on. He developed a production of carpets geometrical in design and made from Icelandic wool unaltered in colour – unbleached white, different shades of buff and black – in fact just as it grew on the sheep.

The original tweeds and a great many other Irish products derive their effect from

a similar connection with nature and, bearing in mind the above examples, we must advise you to take care of this line of production and pay attention to good materials, careful craftsmanship and practical form, as attractive design in our case has developed from an acquaintance with materials, methods of production and the main human requirements.

In common with other nations, Ireland must of course pay attention to passing fashions, but as competition from countries with very big populations is too strong in the field of cheap goods, quality of craftsmanship and design becomes absolutely essential. Here is where the study and understanding of the original Irish culture is of great value, for the penetration of this distinctively Irish spirit into Irish production will develop abilities in the appraisement of forms which will be useful even when leaving the national traditions.

Textiles

The field of textiles is one of the most interesting as far as Ireland is concerned and is of course a wonderful field for designers. On the same loom the same material can produce at the same price a wonderful fabric or a dull, uninteresting cloth. The manufacturer himself may sometimes lose sight of this, preoccupied as he must be with prices, production and tradition. At the same time it is worthwhile to note that the textile field is more influenced by fashion than most of the other commodities we shall discuss. Textiles are one of the big items on the world market, but the successful selling product seems to be unpredictable. It follows that the textile designer must, besides the technical knowledge and feeling for the material, have a flair not only for the rapidly changing fashions as manifested in this year's taste, but also for the more profound transition in the way of life taking place in the world today. However, the designer who takes a trip to London or Paris to try to pick up the colours and patterns which will be in vogue next season, will do his manufacturer a disservice and leave him still only competing in price. What the designer should be able to do is help set the policy of the firm. Textiles are worldwide and the businessman can buy from Hong Kong as well as Milan. A firm in this field must set its goal, have a clear and well-defined aim, and with good production it will surely find its true customers.

In Ireland the industry seems to be divided between firms basing their production on traditional handicrafts and more recently established firms set up to replace imported textile goods and protect against their competition. We feel that many of the faults to be found in Irish textiles spring from this cause. Because they are attempting to replace the foreign-manufactured article, they have tried to imitate it and manufacture a great many lines with a mixture of foreign styles and production techniques. Instead of being Irish, their textile goods are French, English or Japanese, and we know from our experience that this is a disastrous approach. A preferable policy would be to strike out and experiment with new ideas and production methods, to concentrate on a few lines of other countries, and endeavour to produce something of unique design and quality. We believe that ultimately this would be a more economic policy. These remarks do not, of course, apply to all Irish textile mills. Some

Fig 3 Celtic revival porcelain featuring a wolfhound, round tower, and harp, by the Belleek Pottery, County Fermanagh.

of the factories we visited were working on the lines outlined above, but they were exceptions.
...¹

Linen

Irish linen needs no praise. The quality still seems to be the very best. Among the damask patterns we found designs with a somewhat roughly composed naturalism (shamrock and other plant motifs), which hardly did justice to the material. Both flower motifs and geometric patterns can undoubtedly be cultivated to a higher artistic perfection and the quality of Irish linen deserves the very best of damask drawing.

Woollen and Other Woven Cloths

Influence from abroad is nowhere more evident than in this section of the textile industry, and our earlier remarks in this section apply especially to it. The cloths for suitings etc. are largely derivative and the necessity for the development of new ideas and designs is apparent.

Poplin

As far as we know, Irish poplin is woven by only one firm. Materials, colouring and weaving seem to be of the highest quality. The colours are to a rather large extent dictated by tartans, regiment and club stripes, but many of the independent colours and patterns are excellent. We were saddened to hear that because the number of apprentices in hand weaving is so small, one of the main problems is to secure the maintenance of this old trade, which throws such lustre on the Irish population. In our view, because of the distinct and unique nature of the material it has great opportunities on the world market, and strenuous efforts should be made to keep it alive by encouraging apprentices to the trade.

Donegal Tweeds

Probably the most valuable and brilliant facet of Ireland's textile industry. We can have nothing but praise for the production and one of the firms we visited could stand as a model to all others. It occurs to us that the traditional patterns and colours seem immediately more valuable than where the designs are more or less dependent

on changing fashion claims. Therefore we propose the establishment of a tweed museum, which would illustrate the history of the craft/ industry and show the various stages of growth and development, and the techniques used in production. All the old colour recipes, directions on colouring methods, samples of the original ways of spinning and weaving, etc., could be collected and preserved so that fading and other changes are avoided. On the basis of this element a production could be started, the patterns and quality of which would remain unchanged from the ancient ones. The good produced by the industry in catering for changing fashion would thus maintain the high standards acquired through generations. It could be that the collecting of the old materials would result in a revival of the colours and cloths in which people have lost interest and it would be possible for designers, given the opportunity to study the collection, to create variants with influence on the fashion-centres.

Hand Knitwear

Again an excellent industry. The production is based on Irish traditional patterns of great beauty and the quality of the yarn is superb. It would probably be of great benefit if the white wool could be supplemented with natural black or brown, and experiments could be undertaken in spinning together the wools of different colours. (We did not see any black sheep on our travels, but could not somebody breed them?) We do not approve of the tendency, which we noted, to descend to the dyeing of the yarn into fashion colours. In the traditional patterns – rope, diamond, cable, moss – you have a treasure which is capable of further development, but which at the same time must be safeguarded.

Handmade Carpets

The production of tied carpets is of a very high quality but artistic standards need to be raised and could be by the choice of better patterns and designs, and by attention to the finish of the carpets which we consider too shiny at present. A collection of carpet drawings showed that the work of the designer's office was skilful but dull. We were told that the only patterns utilized were dictated by the customers or their architects, so that the entire production is concentrated on supplies for certain places existing or being built. As for goods for stock, nothing is made except a few pieces for exhibition purposes. These latter surpassed in no way the articles made to order. In our view, the industry would be well advised to make their samples works of art in order to animate their customers into buying better drawings than those they usually produce for themselves.

A fine Irish rug ought to be one of the items at the next major international fair or exhibition. The industry should experiment with natural earth colours in conjunction with natural wools, which we think would be suitable for the technique. It could also be recommended that a foreign consultant be employed during the period of transition.
...[2]

Glass

Everyone who sees the Irish glass must initially be impressed. It is a magnificent achievement to develop an industry based on skilled craftsmanship in such a short space of years. The idea of reviving the old

Fig 4 Hand weaving, spinning, and knitting survived as cottage industries into the 1960s.

trade name and basing the production on models from the museum seems good at first sight. What then is wrong? First, the chosen originals are in many cases not good enough, and in any event the industry has moved away from the prototypes as the demand is not covered by them. Today the production can best be described as playing on the layman's sentiments. The glass is excellent and the industry is to be complimented on getting top-class assistance in order to bring the technique to such a high level. Unfortunately the shapes are often not artistically satisfactory and even the copies are not true to the cultivated eye. The relationship between the shape and the decoration is sometimes an unhappy one. Maybe the diamonds are placed a couple of millimetres too low on the glass, for example. It seems perhaps a small point, but details of this sort distinguish the first- from the second-class product. In our view, while technique and craftsmanship have been developed in the industry, the keen eye has been neglected and the natural sensitivity of the artist has not been employed. This means that the industry will not only be unable to advance with new shapes, but will fail to set the standards of performance necessary to keep a tradition alive. We would consider it desirable that the industry, which is doing so outstandingly well commercially and technically, makes a radical re-orientation in its outlook by retaining the services of a top design consultant, to help evaluate the existing situation, and by regular consultation at management level, develop a new and more inspiring policy for the future.

Ceramics

The technical equipment and other facilities in the china and pottery works which we visited are quite satisfactory and sufficient to give a much higher quality of production. In their present state of development these factories could not hope for success in competition with, let us say, the German factories. What is now produced is mainly based on bad English production, both as regards design and form, decorated with transfers which have been imported from England and elsewhere. It follows that the

Fig 5 Waterford Glass was described as "not artistically satisfactory" in the Scandinavian Report. Here a glass-cutter works on a globe, c.1960.

relation between the shape and decoration is haphazard and meaningless. No one can expect an artistic result from having Dutch transfers of an English scene with no specific purpose, put on a cup in an Irish factory. These designs are difficult to change, partly because they are so customary and partly because the patterns are so much in use that even the replacements for the broken sets demand a considerable production. It is unlikely that the form of decoration could be changed in the near future, for it would be difficult to find or train hand painters. Where patterns of Irish origin have been employed they have been treated wrongly and do not fulfil their purpose of being expressions of Irish tradition. Much of the pottery industry's production consists of sets for restaurants and cafés and many of the models are so ordinary that they could be improved by quite small alterations in shape and decoration. The function of the decoration on a shape is what matters and while the identification mark on hotel or restaurant ware probably does not call for a creative artist, it still needs a man with professional insight.

If a draughtsman could be trained to a certain sensitivity to be able to judge how light or how heavy a print should be in relation to a shape and how it should follow the form, it would be quite reasonable for an Irish printer to take up the manufacture of transfers. The demand for advertisement articles alone should keep a printing machine busy.

The managements of the china and pottery factories should consider setting aside money for development work, e.g., for training casters. The casting at present is poor and unsatisfactory and it would be very easy to raise this standard by sending men to study in Denmark where casting techniques are more highly developed than in England. Better glazes and chemicals should be used, which means a more qualified selection and contact with the manufacturers of glazes abroad. At the same time it might be worthwhile to try to interest Irish sculptors and craft potters, who from their professional background have many of the qualities needed to spur an improvement in shape and design. One Irish pottery is producing work of a very high quality through having had the foresight to introduce a technical adviser from abroad. Their problem is one of marketing and design policy rather than the need of any outside help.

A genuine overhaul of the china and pottery industries cannot be carried through, however, if just a printer or a draughtsman supplements the model shop. Original-thinking artists with a complete knowledge of production must be put to work – ceramists who will select the clay, the glaze, the form of decoration. It is clear that without some

radical change in design policy it will be impossible to produce anything but the commonplace.

The Smaller Potteries

The small pottery is a most valuable adjunct to the ceramics industry and there are many cases in Scandinavia where prototypes and techniques developed by individual potters were subsequently put into large-scale economic production by the bigger works. Also the small pottery acts as a stimulus to the industry and as an innovator in new design concepts and developments. Consequently we were very interested in the small potteries in Ireland and visited two of them. Once again it is difficult to generalize, for one was an instance of love and care lavished on a craft and was an example to all connected with the industry. The other had spirit and courage but we felt lacked professional inspiration and education in artistic fundamentals.

Metalwork

We found very few examples of worthwhile design in metal. In cutlery, kitchenware, tools and appliances, the designs seemed to be all derivative and without understanding of the materials. As with glass or clay, a real appreciation of the material and its possibilities is necessary for the designer in metal. The absence of the small workshops and individual craftsmen is possibly responsible for the low standard. In the National Museum, we saw excellent examples of metal handicrafts, cooking pots, forks and oil lamps, simply designed with the emphasis on human requirements and the limitations of the manufacturing processes.

There is no reason why the quality should not be raised, but designers, who must be given the opportunity to study the functional requirements of the various products, must be introduced into the steel and aluminium factories. Electric heaters, we are told, were developed in Ireland and, after satisfying technical requirements, their shape was entrusted to a foreign designer. This is altogether an incorrect approach. The designer must work with the technical staff from the beginning and their talents should complement each other. This is particularly so in regard to tableware, where the copies

Fig 6 Advertisement for the cast-iron products of the Waterford Foundry, c.1960.

Fig 7 Irish linen with machine-embroidered floral decoration, c.1960.

produced reveal no understanding of the originals and have moved far away from practical requirements. To raise the standard an experienced designer should be engaged, who would supplement the technicians, analyse the elements of these articles and produce a consistent functional form. The remarkable success of Danish tableware is based on a detailed study of day-to-day requirements allied with craftsmanship of a very high order. We noted one attractive production of cast-iron kitchenware, but most of the pots and pans, aluminium and otherwise, were completely non-competitive in design and function. The possibility of cooperation with Irish sculptors who are working in metal and have a feeling for shape and form should be explored and might result in new ideas.

It is common knowledge that the commercial success of certain machines, radios and industrial appliances has owed a great deal to talented industrial designers who have not merely been able to make the appearance of the products attractive but have redesigned their complex machinery. We do not know the extent or status of the light engineering industry in Ireland, but if it is intended to develop original products, foreign design talent will be necessary.

Furniture and Articles of Wood

From an Irish point of view this is justly taken as one of the most difficult problems. In the stores, we are told, it is more difficult to sell contemporary furniture than period furniture, despite the fact that the reproduction of the old forms is without any understanding of the original work. The modern furniture is nearly all based on 'Continental models'. Usually plagiarism in furniture degrades the original because there is very little confidence in the joinery and Irish plagiarism lacks all the advantages of the originals. From our point of view it has continually been emphasized that design essentially rests on knowledge of materials and the ways in which they may be treated. The different techniques and ways of manufacture which are the basis of furniture production have been neglected in Ireland.

We are able to find a parallel case in Denmark in the middle of the eighteenth century. At that time Danish joinery was so bad that all furniture of the better kind was imported from England and Hamburg. This situation was remedied by government intervention. Promising craftsmen were sent

to England and after a period of education there, returned with experience and drawings, and an institution – 'De Koningelige Meubel Magasiner' – was established. This institution helped the joiners with technical information and furniture was sold under a label of guaranty. When the organization was disbanded the standard remained high and a distinctive Danish style had developed on English foundations.

A similar action is necessary in Ireland, but it must be so extensive that great sacrifices will have to be made, while at the same time it will not give immediate results. One approach would be to send craftsmen abroad for further training, but our Scandinavian respect for the spirit of the workshop makes us suggest the establishment of an Irish workshop under the direction of excellent foreign designers and craftsmen, where it would be possible to make furniture of the highest quality. The apprentice could, after finishing at the Irish workshop, then be sent out to the 'Teknologisk Institut' in Copenhagen to join the class which is attended by the best young Danish journeymen, working with modern machines and surface treatments.

In the stores and tourist shops we saw some thrown bowls of wood. Their quality was acceptable but not as good as the Danish, which in turn is inferior to the Japanese. The answer must lie in the fine Japanese wood which lends itself to more slender and elegantly designed throwing.

At the National Museum in Dublin, we saw some drinking cups of wood, semi-squared, with either two or four handles, carved from a single piece of wood except for the fitted bottoms. These 'methers' are a characteristically sixteenth-century Irish form, which correctly reproduced, would match modern surroundings very well, and could form the basis of a valuable handicraft activity. If the carving of wooden objects should be entrusted to home workers, it would cost very little to perform a rather close raw form in machine-work, but here also the woods play an essential part. Furniture, thrown articles and carving demand fine wood. We suggested to one of the leading joiners in Dublin that the trade should agree to stockpile timber until matured, supplementing the store as it was consumed. In reply we were told that there were insufficient trees to fell in the country. It may well be that we have touched on a task for the government, because in studying ancient Irish work we have gained the impression that Ireland should be able to supply itself with beech, oak, elm and yew of fine quality.

Souvenirs

The slogan 'The customer is always right' when applied to product design is not alone incorrect, but, in relation to the production of such a commodity as souvenirs, highly dangerous. And yet this we found was the reply when we gave it as our opinion that the bulk of Irish souvenirs are of a very low quality. As very often the country is represented by the small things which visitors to Ireland place in their homes, or give to their friends as 'something Irish', we feel that it is of great importance to have a high standard in the production of souvenirs. The aim should be to give the tourist the type of souvenir he needs rather than that which he merely wants. After all, it need cost no more to produce something worthwhile than to produce a tasteless thing.

We are not dealing here with Irish goods which may be sold as souvenirs, such as a length of tweed, but rather with the souvenir proper; the purely decorative object, or the usable article with an inscription referring to Ireland. These latter fall into two categories, the handicraft souvenir and the factory products. Among good handicraft souvenirs are to be mentioned St Brigid's crosses, the most simple of the rush baskets and a wooden model of a primitive Irish boat. Clumsy reproductions of Irish rustic houses made of painted peat, landscapes produced from tweed stubs – and worthless as landscapes – and similar rough and artless products should not be encouraged.

Some factory-made souvenirs are to be noted because they are often of a better design than others, e.g. cufflinks and simple objects of green marble. The leather goods are too rough and heavy and the copper products seem more scamped than primitive. The earthenware and china are on average of a common and insignificant shape which is not improved by the fact that the tourist factor has been introduced by transfers of poor drawings. In these transfers, and on copper and leather also, the motifs from the Celtic and early Christian times are very dominating. It is regrettable that the oddest of the old ornaments have been utilized, the interlaced animals, etc. They are indeed conspicuous, but at the same time their character is difficult to read. So as we have already mentioned, the modern adaptations of this distinguished art are always depressingly incorrect and ugly and generally seem strange when placed in modern surroundings. If people wish to draw inspiration from the past, they should study the Book of Kells, the stones of Clonmacnoise, etc., where they will find sources of simple drawings and colour compositions which would be quite natural to use, because they are almost modern, and because the reproduction of their character is a practical proposition.

We feel that Irish souvenirs could reach a much higher standard both artistically and technically but the producers are obviously in need of guidance and assistance. For more than fifty years the handicraft people in Denmark have had an association directed by first-class architects and artists, the Handarbejdets Fremme. Special models have been drawn, old handicrafts have been revived and, through a magazine, drawings and working instructions have been sent out all over the country. Additionally, local agents have worked to raise the production to a high standard. In Ireland we noted that these techniques are being employed most successfully in the hand-knitting industry, and during our tour we met people who with training would be capable advisers to the souvenir production industries and the individual craft workers. We would recommend that such talented people should be sent abroad to study production and promotion methods.

…[3]

Notes

1. Sections on Textile Printing and Textile Design have been omitted here.
2. Sections on Machine-made Carpets and Sisal have been omitted here.
3. Sections on Graphics, Packaging and Stamps have been omitted here.

Statement of Practice

Handspring Puppet Company

Adrian Kohler
With contributions by Basil Jones and Tommy Luther

Adrian Kohler and Basil Jones are puppet makers at the Handspring Puppet Company, Cape Town, South Africa.

Introduction

One question that might usefully be asked in the context of a journal such as this is: "What makes puppetry different from other crafts?" This is, in a way, a question about ontology, because it could be argued that a puppet in performance (that is to say, a puppet functioning as a puppet) has a different status to any other craft form: its main objective is to strive to *live*. Putting this another way, a puppet is a craft object which does not function—in a way, does not exist—unless it is being animated by a puppeteer. Here we are assuming that a puppet is by definition an object that is manipulated in front of an audience in order to simulate life. Therefore "seeming to be alive" is in a way the *ur*-narrative of any puppet. This "striving for life" is its basic story, the story that underlies any other story that may be overlaid on it by a script. So "story" and "life" have to be part of the very nature of any puppet.

It helps therefore if this *ur*-story is somehow crafted or built into the puppet. This is where the puppet designer assumes importance. The puppet maker will often design the puppet so as to enhance its ability to emulate life: the limbs and body will bend in appropriate places; the head will turn and nod; and sometimes the eyes will be made out of faceted beads so that they catch the light, and seem to move and therefore "see." Puppet designers must think of the puppet as a kind of semiotic system. We need to analyze how the puppet will function in performance, and try to build into it the potential for as wide a range of signing as possible.

Another difference between a puppet and other craft forms, of course, is that it requires a puppeteer to make it live. You could say a knitted shawl needs a person to use it before it functions as a shawl, or a ceramic pot needs to be filled and used before it is truly a pot. Function is often an important factor with crafted objects. However, puppetry presents an extreme case, as the puppeteer becomes a significant collaborator in the semiotics—the generation of the meaning—of the object. Puppeteers must take up the panoply of signing systems provided by the designer/maker and develop them, with whatever talent and skill they possess.

Thus, in a sense, a performing puppet is always a part of a *gesamtkunstwerk*—a moving synthesis of a number of sign systems, brought about through the work of a number of artists: scriptwriter, designer, maker, and manipulator(s).

In the following article, Handspring's Adrian Kohler examines the creation and performance of a puppet produced for the play *War Horse*, which was adapted from the novel by Michael Morpurgo.

Basil Jones

. .

The story of *War Horse* is set during the First World War. Albert, a farm boy, brings up a foal that his drunken father bought by mistake. When war breaks out, the father sells the horse to the army, where it is soon drafted into German service after surviving a cavalry charge that saw an English officer shot off its back. The horrors of the war are told from the horse's vantage point. It doesn't take sides, but responds to food and kindness as a horse might be expected to do. Albert joins up (under age) and searches for his horse for the whole of the war. Miraculously, at the armistice, when both have been badly battered, they find each other.

My immediate response to this story was positive. We had made a good giraffe in a previous production; we thought a horse should be possible. Tom Morris, associate director at the National Theatre in London, sent us the novel.

The First Workshop

Of course a novel isn't a play. At the flick of a pen, a reader can be whisked away from rural Devon to the trenches of Belgium, from a plowing competition to a cavalry charge, to a full battle scene with tanks and mustard gas. How were we to depict the cavalry charge of 150 horses?

The first workshop for *War Horse* was staged at the National Theatre Studio, a separate building located fairly close to the actual theater. It's an institution where new ideas are grown into projects that might receive a green light. There are rooms for writers and rehearsal spaces. Some ideas have left the building never to be heard of again; many others have gone on to achieve great renown. There are people there who still remember when Peter Schaffer's play *Equus* was in development. This first workshop was held with a try-out writer and a group of actors.

Among them was Toby Sedgewick (who would become the choreographer and create the role of Ted Naracott, Albert's father). Also present was Mervyn Millar, who would recruit the many excellent puppeteers we would be needing, would write a book entitled *The Horse's Mouth: Staging Morpurgo's*

Fig I Joey and Topthorn prepare to lead the Devonshire Yeomanry in their first charge of the war.

"War Horse," and would be one of the leading puppeteers in the first two seasons of the production. Alan Edwards from the National's prop department was seconded to us and together we made quick mock-ups of horse heads and necks out of torn cardboard and shredded newspaper. On a day when the Olivier Theatre stage was completely clear, we were able to take these and a complete life-sized cardboard horse on to the vast round performance space. Sitting high up on the balcony looking down on these "horses" trotting round, the stage seemed built for them. In its bare state it was like a circus ring, an ancient Roman arena.

Model Building and Problem Solving

Back in Cape Town, I built a working cardboard scale model. The anatomy of the horse's legs and those of the humans inside it would not correspond with each other, as they had in our giraffe; there would be eight legs under the horse, not four. But the hands of the puppeteers would be in close proximity to the puppet legs and therefore available for hands-on manipulation, so the legs could be highly articulated. If I could successfully mimic the way a horse's hoof automatically curls under as it is lifted off the ground by the upper leg, I would be a long way toward making credible limbs that would

easily pull focus from the human legs walking beside them under the horse.

Whilst preparing working drawings for the prototype horse from the scale model, I realized that I would need help to build the full-sized version. I had often used cane before in the construction of large figures. But, with front and back legs, head, neck, tail, ears, and weight-bearing body, there were too many new systems to be developed on my own. I put word out for a technical wizard and Thys Stander appeared. Long-time puppet friend Hansie Visagie introduced him to me, with a word of advice: "Give him a problem to solve, and he will be happy."

Over the next four months, a horse that could be ridden started to take shape. For the spine, I enlisted the help of Mark Laubser, a specialist aluminum welder who normally builds boats. The two puppeteers inside would each strap on a backpack. Above their heads the backpacks would be attached to this bridging spine, made strong enough to take a human rider and high enough to protect their heads.

It is important when designing a new figure to ask the question, "How will it breathe?" The breathing action of any figure helps it create the illusion of life. Whilst observing real horses breathing hard after physical exertion, the problem of representing this looked daunting. The ribcage of the animal expanded out *sideways*. Even if I could hinge the ribcage at the spine on either side and develop a means of rhythmically manipulating it outward and inward, the payback would be minimal. Looking at the animal head-on, you would see the movement. Seen in profile it would be hardly noticeable. Our horses would be seen mainly in profile.

The solution proved to be very simple. As in a motorcar, the front legs would be joined to each other by an axle. If this axle were not fixed but given the freedom to move up and down in a slot, the "heart" manipulator, who is attached to the spine above by the backpack, would, with the front legs resting passively on the ground, be able to make the ribcage go up and down simply by bending and straightening his or her knees. This up-and-down movement replaces the more accurate side-to-side expansion of a real horse, but it is more effective because you can see it. No extra hand controls are needed: just the knees.

The construction of the legs themselves presented a more difficult problem. I had designed them to be cut out of plywood and then given three-dimensional shape with added cane. This plywood system had worked well for smaller figures. Scaled up to the full size of horse's legs, though, they were too brittle. Laminated with a strengthening plastic skin, they then became too heavy. Reducing the amount of plywood in the leg would mean augmenting the use of cane. This would in turn have to bear more of the weight and stress. The joining of the smaller plywood segments to the cane was where the problem lay. Any rigid gluing system would wear loose in time. The same would happen with metal straps.

Thys's answer was to literally sew the two materials together. By pre-drilling holes in the plywood along the area to be joined, and then stitching the cane to the plywood with a wire needle and thick, waxed thread, a very effective join was achieved. Although the stitching was tight, it allowed the cane to flex slightly but always to return to its original shape. It was

Fig 2 David Gyasi (as Captain Stewart) and Curtis Flowers (as Billy) ride Topthorn and Joey in the second cavalry charge.

labor-intensive, and hard on the hands—a leather glove is required for extended periods of work—but the result was that the plywood components could be reduced to only those areas of the legs that required absolute rigidity, namely the joints and pivots and hooves. It was a breakthrough. The cane basketwork of the body could now be used structurally in the legs, making them strong, slightly flexible, substantially lighter in weight, and consonant with the aesthetics of the body. By soaking the cane in water, molding each segment in a jig, temporarily wiring them together when dry and then finally stitching them, complex forms that revealed the anatomy of the horse (but that were at the same time structural) now became possible.

The ear and tail movement were the next two major challenges. Both would be very important semiotic "tools" for the horse puppeteers, being the indicators of the thoughts and emotions of the horse. Since our very first Handspring play I have struggled to amplify the driving distance that human fingers can control—that is, to increase the ratio of the movement of a controlling finger to the larger movement in a part of the puppet. When supporting a rod puppet with one hand, the least amount of grip you can use on the support handle is with the small finger together with the ring finger plus the heel of the thumb. Available for use on controls, then, are the stronger digits, i.e. the thumb, forefinger, and middle finger. Each of these has a finite range of

Things were able to cross-fertilize from one department to another. For instance, the skeletal "cane-drawing" of the horse is reflected in the fragmented look of the huge First World War tank that confronts it.

War Horse became the first play for us where neither Basil nor myself would be performing.

With the responsibility of the piece as a whole resting firmly on the shoulders of directors Tom and Marianne, for the first time Basil and I were now able to carefully analyze from the outside what it is that we require from a puppet performance.

From inside the production one cannot judge the overall effect of each character on the others or even whether the principles of puppetry are being effectively applied. In fact we had never formally conceptualized what these principles were, relying instead on instinct and the needs of the moment. Now we needed to teach how a puppet thinks, the importance of stillness, the uses of breath. We had to develop a method.

Although a puppet horse is the primary character in *War Horse*, it doesn't speak. In this first rehearsal period, as the directors grappled with a play adapted from a novel, essentially a devised piece, the bulk of each day was spent on making the dialogue scenes work; time allocated for puppet work being relegated to an hour at the end. By the end of the day, actors were tiring and it was a struggle to prevent these sessions from receding into a second-tier level of importance.

In addition the process of developing fully formed puppet characters in a production as large as this would inevitably be difficult because their presence in the play was not as fully represented in the printed pages of the text as the roles of the human characters were. (In fact the puppeteers have now developed their own parallel text, used amongst themselves to motivate actions from a horse's point of view. This text is passed down orally as "old" horse puppeteers hand over their roles to new teams.) After the first season, the essential role of the puppets had been recognized and the rehearsals of the second season and subsequent West End transfer rehearsals have fully accommodated the requirements of the puppets.

Apart from the exhilaration and love for our craft that participating in *War Horse* has allowed us to feel, there are other more lasting benefits. The puppetry principles that the horses forced us to formulate will be utilized whenever we are required to train new puppeteers or devise a new piece. The technical advances which the construction of the horses demanded will be usable in many different ways by ourselves and anyone else who needs them. Above all however, the puppet has made another loud claim for legitimacy in the theater that has been heard by record-breaking numbers of the theater-going public.

. .

A User's Guide

Tommy Luther, who played the heart of Joey right from the first prototype workshop to the end of the second season at the National, decided not to move with the production to the West End. Here are the notes he wrote (in January 2009) to the person who would replace him.

Here are some notes for people getting to grips with the heart of Joey.

Economy of tension. Try to avoid the entire body being in a complete state of tension as normally happens when learning a new technique. I always find when learning something new that I tense every muscle but the more you become used to it the more economical you can be. Find moments when you are not making an excessive amount of effort. This can be through gravity and the weight of the puppet, its natural swing and gait.

Avoid exhaustion. Walking round in circles becomes tiring and sloppy. Do an average of twelve rounds of "1, 2, 3, 4" then find an intention for the horse to stop, and another to start again. Use the pauses to discuss as a unit what's working, what feels right and what's missing.

Don't knacker the wrists. A lot of the momentum is in the knees; allow the side-to-side movement to be dictated by the shoulders. The more you put into the body (distributing rather than putting everything into tension) the more you will protect the wrists. This will be extremely useful when you have a rider, when you have to kick or lash out, and especially for the gallop.

Get used to the pendulum or natural swing. The brain will say, "When I release the lever the hoof will immediately hit the floor," but in actual fact the release has to happen a moment before because the leg is so long. This will be more apparent in trotting, but be aware of it in walking mode. Practice stamping the foot, or doing a toe tap to get used to this.

Speak to each other. "1, 2, 3, 4," as infuriating as it is, is essential, especially to the person in front. The person at the back can stamp down the hoof on their "1–3" count, but the tendency of the person at the front is to clench the lever (which will bend the toe, elbow and shoulder joint) on the "2–4" count, when they should be releasing it so that it is the hoof making contact with the ground in rhythm of "2–4." Make sure it is 1–2 (DeeDum), 3–4 (DeeDum), with a minor gap in between.

Quality of movement. Trying to establish movement and rhythm patterns is monotonous and tiring. Add the different states of energy or intention and it tells a story and becomes interesting.

Breathing. There's only about 10 cm to work between full inhalation and complete exhalation. From inside the horse this might not appear like much, but from outside can be extremely effective. The breathing can be

Fig 4 Joey with manipulators Craig Leo (the head), Tommy Luther (the heart), and Toby Olié (the back legs and tail).

felt by the other manipulators even without vocalization (it's sometimes good to close the eyes to check that you can feel this), but vocalizing is a huge help to the others. It carries the emotional resonance of the animal. It is essential that all three actors support this for the horse to achieve its full capacity. This varies between supporting, sustaining, beginning, ending, or contributing a different tone or sound (like harmonizing high with low, or mixing an inhalation with a snort).

Breathe in the knees. This may seem emotionally disconnected and awkward, and it might feel more alive if you communicate it in the shoulders or by arcing the back and flexing the core muscles, but it will save your spine if you get used to this early on. When you have a rider on your back you want to have full support on the back muscles and let the thighs do the breathing.

Thought process of the horse. As this all comes from the head, the two people inside the horse must always read what the head manipulator is suggesting with the head. Direction is the first concern. But the height of the head, the angle of the neck and head, and the position of the ears communicate several intricate stories. Try to spend more time reading what the head is thinking and less time being meticulous over the feet patterns. Joey's reactions and inquisitiveness are more fun to do than walking patterns (and plenty of time will be spent on that).

Tommy Luther

Acknowledgements
All photos are by Simon Anand, courtesy of Handspring Puppet Company and the National Theatre. *War Horse* is running at the New London Theatre through February 2010.

Exhibition Review

Craft in its Gaseous State: *Wouldn't It Be Nice ... Wishful Thinking in Art and Design*

Museum für Gestaltung, Zürich, February 8–May 25, 2008. Produced by Centre d'Art Contemporain, Geneva, October 26–December 16, 2007, in partnership with HEAD, Geneva University of Art and Design and Museum für Gestaltung, Zurich. Also on display at Somerset House, London, September 17–December 21, 2008

Reviewed by Mònica Gaspar

Mònica Gaspar is a freelance curator, writer, and lecturer based in Zurich and Barcelona.

Curating exhibitions on the blurred territory between art and design is not an easy task. Critical and conceptual practices in contemporary design try to negotiate an intermediate position between otherness and integration within their respective disciplines and in the landscape of everyday objects. To develop a language for reflecting about and displaying those artifacts is an important challenge for curatorial practice today.

The project *AC*DC Art Contemporain/ Design Contemporain*, initiated by the HEAD, Geneva University of Art and Design and the Centre d'Art Contemporain Genève, offers an impressive example of how to deal with the above-mentioned issues. The simultaneous organization of an international symposium, master classes, and lectures by eminent speakers such as theorists Hal Foster and Paul Ardenne, together with the touring exhibition under review, constantly enriched by works in progress, performances and workshops, created an exciting constellation.

The point of departure for the exhibition *Wouldn't It Be Nice … Wishful Thinking in Art and Design*, curated by Katya García-Antón and Emily King in collaboration with Christian Brändle, was an invitation to five designers and five artists to materialize a wish, making use of utopian thinking as experimental tool. Designer Jurgen Bey built a model of his studio in miniature. Made of foam, the object suggested a metaphor of lightness and freedom for an autonomous working space. Reflecting on issues of authorship, visual artist Tobias Rehberger presented sculpture as a DIY original to be copied by the audience, who could purchase a license to that end *in situ*. Bless, a fashion design duo, presented a re-design of holiday hammocks, adapting them to urban, indoor environments. Their macro-scale knitting technique blurred objects' genre (sculpture or furniture?) and gender (what could be seen as a clichéd feminine knitting work looked like an over-dimensioned "SUV-hammock"). The car fantasy materialized at the London display, where Bless presented a life-sized model of a car made of foam and leather, to be used as sofa. Artist Alicia Framis reflected on globalized working conditions in the project *China Five-Star: 100 Ways to Wear a Flag*. Designers and theorists Anthony Dunne and Fiona Raby, together with designer Michael Anastassiades, presented critical objects to deal with various contemporary anxieties. Even the catalog engaged in utopian proposals: Graphic Thought Facility designed a publication that looks like a lifestyle magazine. Instead of advertising inserts, long sequences of blank pages and blank brochures create free, unsponsored space.

At the Zurich venue, the objects were mostly positioned on the floor in an open plan space. The generosity of the room gave to the works a strong sculptural character. In addition to the possibility of interacting with some works, several events took place in each venue. For example, in Geneva, graphic design group Dexter Sinister installed a fully functioning printing workshop inside the exhibition. In Zurich, Martino Gamper transformed the exhibition space into a workshop and built furniture, assembling old and new in unexpected constellations. In London more performances, such as the ongoing *MacGuffin Library of Objects* created on site by Noam Toran and Onkar Kular, accompanied the show, contributing to a full and versatile program that partially ran alongside the London Design Festival.

The curators of *Wouldn't It Be Nice …* bet on those "modest forms of utopianism"[1] developed by the ten exhibiting artists and designers in order to inspire a more critical and creative way of living. If that objective did not always come across clearly, that tells of the complexity of communicating and displaying these kinds of projects. As example, Dunne and Raby's *Hideaway Case*, made in collaboration with Anastassiades, refers so strongly to minimal sculpture that it is difficult to think of it as emergency furniture, even on a metaphorical level. However, there is no doubt that the participating artists and designers take independent positions away from mass production. They give priority to processes and durations, set up relational situations, and offer precarious solutions with a kind of low-tech aesthetics. Some of the resulting objects are self-reflective. Others engage critically with the present, adopting serious, playful, or poetic formats. They exist as one-offs, as limited editions, or stay ambiguously between

Fig 1 Installation view of *Wouldn't It Be Nice ...*, installed at the Museum für Gestaltung, Zürich, with Ryan Gander's *If I Could See But A Day Of It* in the foreground and Martino Gamper's *Gallery Furniture* in the background. Photo: Mònica Gaspar.

prototype and finished product in order to involve the user in a conceptual or material finalization.

The name of "contemporary craft," as it has been redefined recently, seems suitable to describe the positions of some of the exhibiting practitioners. In his essay *L'Art à l'état gazeux*,[2] Yves Michaud argued that art has reached its gaseous state, leaving its ritualized circles of production and reception and reaching every single aspect of contemporary existence. One could claim that craft too has volatilized, expanding its meaning beyond its specialized world and infiltrating conceptual and critical positions in contemporary practices. This could be one of the reasons why a craft attitude is not explicitly mentioned in the exhibition, even through the personal experience of rehearsing, manipulating, and producing. In short, the chance to participate in the making of the material culture of everyday life is at the core of the selected projects. "Craft In Its Gaseous State" acts as experimental tool or as perspective for the analysis of contemporary objects. Whether this perspective can help to develop new curatorial languages for cutting-edge work is a change of state worthy of further exploration.

Notes

[1] Katya García-Antón, Emily King and Christian Brändle, eds., *Wouldn't It Be Nice ... Wishful Thinking in Art and Design* (Geneva: JRP/Ringier, 2007), p. 61.

[2] Yves Michaud, *L'art à l'état gazeux. Essai sur le triomphe de l'esthétique* (Paris: Hachette, 2004).

Exhibition Review

Quiet Persuasion: Political Craft

The Society of Arts and Crafts, Boston, Massachusetts, USA, May 9–July 27, 2008

Reviewed by Geraldine Craig

Geraldine Craig is Associate Professor and Department Head at Kansas State University.

"Political Craft" included the work of nineteen contemporary artists, each offering a response to political conditions in the United States during the summer preceding a historic presidential election. Curator Fabio Fernandez took a political poll of sorts, which would reflect the current climate of the nation. While his selection and installation demanded intellectual engagement from the viewer in its mixing of distinct political issues, it was well paced, with modestly scaled work to suit the space. When viewed in the historic brownstone gallery space of the Boston Society of Arts and Crafts—with its marble fireplace, moldings, bay windows, and winding staircase—the exhibition served as an opportunity to reassess the political potential of craft. Can it still be considered a political act to make a domestic functional object, when the art world presents ever-larger biennial installations, Guggenheim-scale spectacles, and city-wide performances?

This is, of course, familiar terrain, as artists using craft have negotiated issues of domestic scale and public vs. private space since at least the 1960s. Robert Arneson's antiwar ceramic sculptures expanded in size beyond the traditional vessel, and Judy Chicago's *Dinner Party* was never viewed in the space of domestic labor that it honors. Today, such collectives as Liz Collins's Knitting Nation gather protest communities to make their concerns public, while queer communities gain strength and solidarity through online quilting and knitting groups. Against this diverse backdrop, bombs on a candy dish or anti-consumerist text printed at the bottom of an empty bowl might seem a kind of liberal

conservatism. "Political Craft" was filled with familiar left-wing messages and timeworn protest iconography. Yet if these intimate objects demonstrate conventional aesthetic strategies, they may have new significance in a time when covert government surveillance and phone tapping are collapsing the presumed border of the private sanctuary of home.

Not surprisingly, criticism of the Bush administration's military policies was the most prevalent theme. *Dark Victory* (2008) is Jeff Crandall's satire on the erosion of democracy: a shelf, champagne glass, and ten empty bottles etched with the Presidential Seal or a text (Guantanamo, Party Loyalty and so forth). The piece suggests how the Bush empire, with its multiple abuses of power, drained goodwill from the world and emptied out the US economy, except the protection offered to those invited to the party. *Ruins #3* (2006) and *Cube Skull* (2006), Richard Notkin's small terracotta renderings of bombed architecture and squashed skulls, capture in miniature complex political narratives played out on a global scale.

The fear-mongering that attends public support for war was an important subtheme.

Yumi Janairo Roth's embroidered towels have simple illustrations and instructions for what citizens should do in the event of biological, chemical, or nuclear attack, taken from the US Homeland Security website. In *Domestic Tranquility: Towels for Everyday Living* (2003), her ironic treatment of the signs of impending disaster plays on how insidious the US government has been, infusing public regulation into private life on an object that is normally used for cleaning up. David Adey cuts apart and reassembles equally humble materials—dozens of identical casts of kitsch ceramic lambs—into a bloated shark or bomb with pink neon wings of an angel. *The New Lamb* (2007), nestled in the bay window overlooking tony Newbury Street, implicates societal overconsumption and a demand for cheap goods as one trigger for war. A portent of destruction, it also implies an evolutionary cycle backwards in time, as chopped lamb hooves are reduced to a means of centipedal locomotion.

While frustration with the Bush administration was the strongest current in the exhibition, some artists reflected upon the politics of race during an election that

Fig 1 David Adey, *The New Lamb*, 2007. Ceramic, neon and mixed media; 61 × 35 × 25 in. (155 × 89 × 63.5 cm). Photo courtesy of the artist.

included an African-American presidential candidate for the first time in US history. In Sonya Clark's *Afro Abe II* (2008), a five-dollar bill transformed with French knot embroidery rendered Abraham Lincoln with an Afro that grows past the border of the bill. The piece might be seen as an homage to the political DNA of a future president, made possible by Lincoln's emancipation of American slaves. Brandon Wallace's *White House '08* (2008) features portraits of candidates Clinton and Obama on opposite sides of a simple, house-shaped ring. It bestows gem-like value to a moment when the return of authentic democracy felt possible again, seen in this unprecedented choice between a woman and an African-American. Wallace's exquisite *Slave Ship* (2006) necklace was not a direct reference to the election, but rather of deeper roots. It offered an arresting dialogue with Joyce Scott's *Devotee* (2003), a three-dimensional bead drawing where physical attributes such as cheekbones and lips are distorted to unnatural proportions, utilizing tension in the materials. Her analogy represents perceptual distortions wrought by generations of racial prejudice that have persisted since the US Civil War. Lincoln appeared again, here in a tiny daguerreotype image.

Other work in the exhibition dealt with the ecology-energy battle, poverty, religion, and sexuality, all treated with the same high level of originality and artistic skill while avoiding the pitfalls of propaganda. Viewers have come to expect political subjects in the fine art world of sculpture, installation, etc. Less often discussed is how meaning translates to viewers when

Fig 2 Brandon Wallace, *Slave Ship*, 2006. Copper, silver and paint; 24 in. (61 cm) long. Photo courtesy of the artist.

embedded in domestic-looking objects made of craft materials. The impact of such works is altered when seen in a historic mansion rather than a white cube; they would have been different again if they had been covertly placed in the global retail market. The Society of Arts and Crafts, with its nineteenth-century ambience, is steeped in the goal of the historical craft movement—to oppose the sterility of mass production with handmade goods. Yet the viewer is confronted with handmade goods where the politics extend beyond the value of hand labor. They prompt us to ask whether subversive messages in craft objects can serve to shape attitudes through quiet persuasion. What was most engaging about these objects of labor, no longer in opposition to industrialization but still largely outside of it, was the reification of lived experience in craft objects where the personal becomes very political.

Book Review

A Theory of Craft: Function and Aesthetic Expression
Howard Risatti

The University of North Carolina Press, 2007. US$39.95 (hardback). ISBN: 978-0-8078-3135-9-1

Reviewed by Sandra Alfoldy

Sandra Alfoldy is an Associate Professor of Craft History at NSCAD University.

Howard Risatti's *A Theory of Craft: Function and Aesthetic Expression* is a contentious and rewarding book. Written in a conversational tone and loaded with craft, art historical and aesthetic references, Risatti makes it his duty to challenge many of the preconceptions that exist around craft. The book is broken into four parts: Practical-Functional Art and the Uniqueness of Craft: Questions about Terminology; Craft and Fine Art; Issues of Craft and Design; and Aesthetic Objects and Aesthetic Images. In the Preface, Risatti sets himself up to tackle the huge question, "What is a craft object?" (xiii). Despite any cynicism that such an undertaking is possible in a mere 352 pages, it appears that he comes remarkably close to achieving his goal.

The order of the four sections means readers are thrown immediately into the art/ craft debate, and as this is a decidedly unpopular topic these days, many readers will find themselves stepping away from the book before they give it a fair chance. Buried within the many and varied chapters of *A Theory of Craft* are useful challenges to our modern preoccupation with pretending that the art/ craft debate is over. *A Theory of Craft* offers convincing evidence that craft theory and critical writing is geographically specific. Risatti's voice is distinctly American; from his assertion "Because the craft field lacks a critical theory that is specifically its own, when critical judgments are made about craft objects they

tend to revolve around the fine art notion that functional things cannot be beautiful and cannot be art" (xiii) to his discussion of the recent dropping of the term "craft" from the California College of Art and the former American Craft Museum (now the Museum of Art and Design), Risatti's views differ significantly from those coming out of Britain, for example. In fact one may be surprised by the lack of British references in *A Theory of Craft*. Imagine an entire history of craft, art and design with only a footnote to William Morris (19n4) and John Ruskin (215n20), and not a mention of Augustus Pugin.

What Risatti accomplishes in this book is setting up carefully considered and well-argued positions on a range of topics to do with the crafts. First and foremost is his controversial assertion that genuine craft objects are always functional. Throughout the book, he returns to the idea of craft belonging to three distinct "sets": those that contain, cover and support. In Chapter 2, "Taxonomy of Craft Based on Applied Function" (29–40), Risatti employs a sociological approach to work through the "unique features that define [craft] as a separate class of applied objects" (29). His system of sets is based on material, process and technique, and form or morphological classification. To further his controversial position on the crafts, he argues that jewelry, tapestries, stained glass, mosaics, and ceramic tiles do not qualify as areas of the crafts under his taxonomy "because they are neither containers nor covers nor supports" (35).

The strongest section of the book is Part III, "Issues of Craft and Design" (151–206). Here, Risatti offers up a much needed discussion of the parallels and differences between these fields while providing the important reminder that, "After all, in the modern industrialized world, it is not fine art but design that has marginalized craft by usurping its primary role of making functional objects" (153). With the advent of the 1661 Manufacture Royale des Meubles de la Couronne Paris under the direction of Jean-Baptiste Colbert, the crafts were absorbed as "elements of a larger decorative design scheme" (154) subservient to the designer's vision, which resulted in the "loss of autonomy of individual works of [craft as] art" (155). Therefore, the "opposition between craft as a unique individual expression of a craftsman not subject to a collective style or movement, and design as a plan reflecting a predetermined overarching style … is fully realized with the advent of industrial production in the late eighteenth and nineteenth centuries" (155). Risatti goes on to examine ideas surrounding manual skill, and creates an interesting relationship between Aristotle's praxis and theoria and David Pye's "workmanship of risk" and "workmanship of certainty" (162–70) in order to discuss the binarism between mental conception and physical execution. He provides an excellent discussion of Mies van der Rohe's "Barcelona Chair" and Marcel Breuer's "Wassily Chair," and traces how "In suppressing the hand and hence the presence of individual spirit, such works intend to create an almost palpable sense of a perfect utopian world of entities" (204), one where craft was at odds with the goals of industrial design.

In Part IV, "Aesthetic Objects and Aesthetic Images," Risatti's expertise as an art historian shines through. This section contains a wealth of references to aesthetic

theory, and Chapter 20, "A Historical Perspective of Craft and Aesthetic Theory," sets up a helpful summary for students and teachers. Risatti is aware that many of his readers will differ with his assertion that craft is defined through function, and he addresses this point in the final chapter of the book, "Development of the Critical Objects of Studio Crafts." He concludes, "Even through function may no longer be practically possible because of size and weight [of the new craft sculpture], that it is still theoretically possible sets up certain tension in the object that comes from within the field of craft" (290); therefore, function is still the main determinant.

Tucked away on page 209 is this insulting quote from H. W. Janson's standard art history text: "If [the art student] senses that his gifts are too modest for painting, sculpture or architecture, he is likely to turn to one of the countless special fields known collectively as 'applied art'." The quote reminds the reader why it is important to have Risatti, a professor emeritus of art history, engaged in such a deep discussion of the crafts. He offers a sustained examination of the aesthetic and historic factors that determine craft while providing new approaches like those contained in his taxonomies. This book is not only an important source of debate for people within the field, it is certain to be a useful teaching tool to engage students with some of the central questions around the push to place craft within the fields of fine art and design.

Book Review

Designing Modern Britain
Cheryl Buckley

Reaktion Books, 2007. UK £17.95 (paperback). ISBN: 1-86189-322-2

Reviewed by Peter Hughes

Peter Hughes is the Curator of Decorative Arts, Tasmanian Museum and Art Gallery.

Designing Modern Britain is a history of British design in the twentieth century written by Cheryl Buckley, Professor of Design History at the University of Northumbria. It is no coffee table book of the sort that provides a simple linear narrative signposted by star designers and iconic designs. This is immediately evident in the scale of the book; at 8½ × 6¾ in. (22 × 17 cm) and 256 pages, it does not lend itself to the large, lush illustrations that characterize such publications. Although there are 130 illustrations, 46 in color, the focus here is clearly on the text. Buckley's aim is to examine design not simply as "things" but as a "matrix of interdependent practices" and to consider "the ways in which it represented and constructed modernity at crucial moments from the end of the nineteenth century to the beginning of the twenty-first" (p. 7).

 Designing Modern Britain is divided into six chronologically ordered chapters, each of which each covers roughly two decades. Buckley has avoided the usual stylistic divisions, such as art nouveau, art deco or 1950s pop, giving her chapters thematic subtitles, such as "'Going Modern, but Staying British': 1930 to 1950" and "The Ambiguities of Progress: Design from the Late 1960s to 1980." By so doing, she has been able to create a fluid narrative, free of the lock-step sequence of stylistic developments that characterizes much design history. This narrative is built up through a number of thematic threads that surface and resurface throughout the text. In addressing design in particular—as the warp through

which these weft threads are woven—her account focuses on industrial and interior design as well as architecture and town planning. While the studio crafts form part of this account, they are a minor one. The crafts enter Buckley's narrative in two ways: through the formidable heritage of the Arts and Crafts movement and its slow demise, and through the subsequent rise of the studio crafts and their complex relationship with modernism.

The two main axes determining the narrative field of *Designing Modern Britain* are modernity and identity; within these lies the particularly vexed issue of modernism in architecture and design. During the nineteenth century, Britain was at the forefront of modernity; it had been precocious in developing a consumer culture in the eighteenth century and consequently became the first European nation to industrialize on a large scale. Britain also created an empire that, at its apogee at the end of the nineteenth century, was the most extensive the world has known. An awareness of this heritage continued to inform the British sense of identity throughout the following century: for surely some intrinsic quality of the inhabitants of this comparatively small island nation and their culture must be the source of these great achievements? Britain's pioneering industrialization, however, also led to some of the earliest reactions against its negative social and environmental impact. The Arts and Crafts movement, with its underlying utopian socialist and reformist ideologies, was an important and highly visible aspect of these critiques in the second half of the nineteenth century. The movement continued to cast a long shadow over Britain's twentieth century, serving to complicate the reception of modernist design and its pro-industrial philosophies.

Early in *Designing Modern Britain*, Buckley traces the twentieth-century history of the Arts and Crafts movement as it is progressively stripped of its reformist critique and devolves into a collection of stylistic attributes to join, ironically enough, the panoply of British nationalist and reassuringly traditional styles. She describes how, in the early years of the century, a less radical version of its original political motivations survived in the suffragettes' use of needlework before the First World War, in the Garden Cities movement, and the early efforts of the Design and Industries Association to bring affordable and good design to all. Shifting her focus from the mainstream, Buckley describes the resilience of the Arts and Crafts in Scotland, where practitioners such as the embroiderer Jessie Newberry at the Glasgow School of Art and Phoebe Anna Traquair in Edinburgh remained loyal to Ruskinian values. Scotland, however, had also witnessed a more indicative turn in design from social issues to stylistic ones. The "Glasgow Four"—Charles Rennie Mackintosh, Herbert McNair and Margaret and Frances Macdonald—were influenced by developments in Europe and moved away from the vernacular promoted by the Arts and Crafts movement toward an abstract and universalizing aesthetic.

Perhaps ironically, the Arts and Crafts movement's anti-urban identification with the countryside and its conjuring of the past through continued engagement with traditional crafts was easily subsumed into conservative ideas of "Englishness" that were central to certain dominant understandings

of "Britishness." Buckley describes how a particular part of the island, the southeast and London, was repeatedly used to stand for the whole nation, eclipsing the English regions as well as Scotland, Wales and Northern Ireland. She notes the tension between progressive, modernist members of the design profession and the more conservative, pragmatic approach of manufacturers and retailers. She cites a Waring and Gillow catalog of 1903, stating their aim to combine "modern methods, and the resources of modern machinery, with what one may venture to call a splendid ancestry," and Lord Waring's 1924 criticism of the "excessive individualism of the Continental school" (p. 75). These constructions of British identity made modernism of the kind promulgated by the Bauhaus in the 1920s and architect-designers such as Le Corbusier highly problematic in Britain, and its influence during the 1920s was limited.

Despite this, Buckley argues that the crafts served as a vehicle for modernist aesthetics by mediating between the harshness of its geometry and abstraction and notions of British/English traditions. She describes how the growing interest in preindustrial and non-Western design was one important point of entry. For example, the potter William Staite Murray (1881–1962) studied historic Chinese and Korean ceramics and developed an aesthetic consistent with modernist truth-to-materials philosophies that eschewed decoration and was based on simplified, well-crafted forms and spectacular glaze effects. Equally, Britain's preindustrial pottery tradition was seen to embody both expressive spontaneity and truth to materials, offering an alternative to the perceived deadening effects of industrial perfection and conservative commercial decoration. In the 1920s ceramics was identified as a plastic art, and Buckley provides a full account of the relationships among potters such as Staite Murray, collectors of oriental ceramics, the critic Roger Fry, and the Omega Workshops. This modernizing aesthetic, in turn, bounced back to influence the industry that it had criticized, and Buckley describes how firms such as Wedgwood withdrew elaborate Victorian and Edwardian designs and turned to the eighteenth century for inspiration. A similar turn to the Georgian is observed in furniture design and architecture, uniting conservative notions of Britishness with a simplified, quasi-modernist aesthetic.

The contribution of women to twentieth-century British design is one of Buckley's major themes and is evident in her accounts of the influence of the crafts in ceramics and textile design in the 1920s and 1930s. Potters such as Katherine Pleydell-Bouverie and Norah Braden were inspired by Tang and Song ceramics and believed that their work should express the intrinsic qualities of materials. Pleydell-Bouverie is quoted: "I want my pots to make people think, not of the Chinese, but of things like pebbles and shells and birds' eggs and the stones over which moss grows" (p. 78). The designer Susie Cooper embraced both decoration and modernism, designing mass-produced wares that accommodated the consumer's desire for decoration with a simplified, graphic form of pattern making. In textiles, the weaver Ethel Mairet had traveled widely and, under the influence of traditional Ceylonese, Yugoslavian and Scandinavian designs, moved away from the naturalistic decoration that had characterized Arts and

Craft textiles. Phyllis Barron and Dorothy Larcher formed a partnership in 1923, designing and making block-printed textiles. Once again, non-Western traditions—Larcher had traveled to India—provided a point of contact between crafts traditions and modernist aesthetics. Their designs referenced natural forms and deliberately eschewed the technical perfection of industrially produced textiles, but they were also emphatically concerned with surface, color, and technique over representation.

With rising criticisms of modernism from the 1950s on, the position of British design changes considerably. Beginning with pop art in the 1950s and developing into postmodernism from the 1960s, artists and designers embraced popular culture and historicism. From the 1950s on, Designing Modern Britain focuses more narrowly on industrial design, as the crafts spin off to become an increasingly autonomous field of practice associated more closely with the fine arts than with industry. While the market for crafts remained strong after the 1950s, crafts practitioners were more often influenced by developments in the fine arts and popular culture than by the concerns of industry. Notions of truth-to-materials, rational design, and perfection of form, in the crafts as elsewhere, tended to give way to a communicative aesthetic.

Buckley's account is largely one of Britain's particular position in the twentieth century and how this had made an acceptance of modernism there difficult. There is no doubt that parallel struggles with the universalizing idealism of modernism in design and architecture occurred in their own way in many places. Buckley's book is refreshing inasmuch as it avoids a simplified linear narrative of progressive enlightenment toward the inevitable. It focuses, rather, on the concrete, the contingent and the particular, emphasizing and celebrating complexity and contradiction. While Designing Modern Britain is not specifically about the crafts in twentieth-century Britain, its account of the complexities of design culture, and of the role of the crafts in it, will be of value to any student of the history of the crafts as an integral product of, and contributor to, material culture. For the student of design more generally, Buckley's account goes some way toward explaining the intriguing peculiarity of British design from 1900 to the 1950s. The book also provides a background to the nation's later comfortable embrace of design in the 1980s and 1990s and the knowingly ironic phenomenon of "Cool Britannia."